ART AND THE ROMANS

Current and forthcoming titles in the Classical World Series

Classical World Series

ART AND THE ROMANS

Anne Haward

Bristol Classical Press

General Editor: John H. Betts
Series Editor: Michael Gunningham

Cover illustration: Leda and the Swan, based on mosaic at Paphos, Cyprus.
[Drawing by Philippa Drakeford]

First published in 1999 by
Bristol Classical Press
an imprint of
Gerald Duckworth & Co. Ltd
61 Frith Street
London W1V 5TA

A catalogue record for this book is available
from the British Library

ISBN 1-85399-558-4

Printed in Great Britain by
Anthony Rowe Ltd

Contents

List of Illustrations

Acknowledgements

For kind permission to reproduce photographs, the author gratefully acknowledges the following:

Fig. 5.3	By courtesy of the Visitors of the Ashmolean Museum
Figs. 1.2, 5.2, 6.2, 6.4	By courtesy of the The British Museum
Fig. 6.1	© the British Museum, British Museum Press
Figs. 1.4a, 2.2a	Museum of Classical Archaeology, Cambridge
Fig. 2.2b	By kind permission of the Earl of Leicester and the Trustees, Holkham Hall
Fig. 6.5	Römisch-Germanisches Museum/Rheinisches Bildarchiv Köln
Fig. 4.5	Reproduced with permission of Somerset County Council Museums Service

The following have kindly consented to the publication of photographs taken by the author:

Figs. 2.1, 3.5, 3.6	Il Ministero per i Beni Culturali e le Attività Culturali, Soprintendenza Archeologica, Naples
Figs. 2.3a, 3.1, 3.3, 3.4, 3.8, 4.6, 6.6	Il Ministero per i Beni Culturali e le Attività Culturali, Soprintendenza Archeologica, Pompeii
Figs. 1.1, 1.3a & b, 1.4b, 1.5, 2.8a & b, 3.7, 4.1, 4.2a, 4.3	Il Ministero per i Beni Culturali e le Attività Culturali, Soprintendenza Archeologica, Rome

Remaining drawings and photographs by Anne Haward.

Preface

'Art is for Looking At' may seem obvious but in the area of Roman art it very easily becomes 'Art is for Knowing About'. Any study should begin with looking at Roman art in whatever way possible, ancient sites, museums, private art collections, illustrated books, photographs or web sites. This book is offered not as a substitute for looking or as a history but as an aid to noticing some of the particular features of Roman art and some of the underlying ideas and influences.

> He marvelled at the skill of the artists and the scale of the works
> ...Trojan Aeneas gazed in wonder at all this, amazed and utterly
> engrossed at the sight. (VIRGIL, *Aeneid* I 455, 494-5)

When Aeneas arrives in Carthage he approaches the temple of Juno and begins to inspect its glories. There he finds painted scenes of the Trojan War and studies them with a mixture of wonder and grief. With what emotions and expectations did Virgil's contemporaries study the statues and reliefs with which Augustus adorned his new Forum? What was the impact of the looted works of art displayed by victorious republican generals? What are the results when choices in art are made by the patron rather than the artist? These are some of the questions to bear in mind when considering Roman art, trying to steer an open-minded way between 'everything Greek is good' and 'everything Roman is inferior'.

My grateful thanks go to Joyce Reynolds and Suzanne Theasby who have fitted reading the draft version into their busy lives, as has the Series Editor, Michael Gunningham, whose suggestion it was that I should tackle the subject. Their comments and suggestions have been most helpful, though the views and faults are my own. To all those who have listened to talks on Roman art or accompanied me on tours of Italy, I am indebted for learning the kind of questions they wanted answered. Finally I must thank my husband, Cyril, for his support and for letting holiday destinations be dictated by my quest for photographs.

Chapter 1
Portraiture

What can we tell about people from their portraits? Today we are more used to looking at photographs, but these usually show people in a particular situation and with a momentary expression. A portrait aims to be a more lasting record. Hundreds of portraits of Roman men and women survive and may be found in every gallery of Roman art; a close look reveals a good deal about the Romans and what they expected of art. Things to consider are what instructions the artist might have been given, what techniques he used and whether the portrait seems to have been honorific for public service, or private. In museums and art books portraits are usually dated and this affects the style; notice whether the time honoured qualities stressed in the early books of the Roman historian Livy, *constantia, fortitudo, prudentia* (steadfastness, courage and good sense) are visible: or do the faces show the *luxuria* of court figures under the Empire?

The Etruscans had placed reclining figures of the departed in stone or terracotta on the covers of sarcophagi. As time passed these were not idealised but showed balding figures with believable faces. As the Romans conquered Etruria city by city, they seized and adapted much that was Etruscan: divination, the arch, water engineering and also portrait sculpture. In the fashion of conquerors they then belittled the people from whom they had derived so much. In addition the Romans had their own tradition of portraits deriving from the *imagines*, death masks, of noble families. According to the Greek historian Polybius these were 'masks of particularly accurate likeness as to moulding and features' (VI.53). Pliny the Elder, whose *Natural History* books XXXIV & XXXV are a valuable source for the subject of Roman art, tells us they were displayed on a separate sideboard (*Nat.Hist.* XXXV 6). As Rome's conquest spread through Italy, Sicily and beyond, the art treasures of the conquered cities poured into Rome and were put on display. After the surrender of the Aetolians in 189 BC M.Fulvius Nobilior is reputed to have brought 785 bronze and 250 marble statues to Rome, and fifty years later, after the capture of Corinth, L.Mummius presented works of art to cities in both Italy and Spain. The *nobiles* studied and imitated Greek

literature and oratory, collected Greek art and soon there was a demand for Greek artists to create portraits to Roman orders. These portraits might show the whole figure or just the head and shoulders, whether they were private commissions or for public display. Different motives were involved in the case of the portraits of the emperors and we will consider these later.

Portrait Statues

Because of the Roman desire to record both historic events and personal achievements, there was a tradition of erecting statues and busts not only in Rome but in cities throughout the empire. In Rome statues of traditional heroes like Horatius Cocles who 'kept the bridge' or Quinta Claudia, famed for her part in bringing the cult image of Cybele safely to Rome in 204 BC, were publicly displayed, and by 158 BC so many busts and statues of individuals had been erected, often by their clients, to commemorate magistracies and benefactors, that the Senate banned them from the forum. In towns all over the empire, however, honorific statues continued to be sited in public places. Upwards of fifty statue bases were found in the forum at Pompeii honouring prominent citizens. In the Naples Archaeological Museum can be seen two examples of the most prestigious form of honour, equestrian statues. These two statues from Herculaneum both illustrate the problems that sculptors had – the impossibility, when working in marble, of supporting the rider and the body of the horse on the horse's legs alone (the solution was a pillar-like support below), and of showing the rider in a dignified and comfortable static pose on horseback before the invention of stirrups. For his part in financing public buildings M. Holconius Rufus of Pompeii was awarded a statue showing him in military dress. These military statues of civilians seem to be part of the desire of Romans to identify themselves with the imperial styles of portraiture, which led to the copying of clothes, hair styles and poses; Holconius' stance is much like that of the figure of Mars Ultor from the Forum of Augustus.

There are one or two statues of individuals where the subject is shown naked or with draperies about the hips and given the ideal torso of a Greek statue by Polycleitus topped with a portrait head, which makes for an uneasy representation. In general however Romans, following the Etruscan example, preferred togate statues to the heroic nudity of the Greeks, especially during the Republic. Yet compared with the Greek statues like the draped figure of Sophocles, there was little interest in the challenge of showing the form beneath the draperies; the concern was the dignity

the toga conferred and the portrait head. Although the bulkiness of the garment is well conveyed, any individuality is scant as these statues were often workshop made before the head had been carved by the master sculptor, and by the first century AD the statues were being re-used and given new heads by the expense-conscious, a practice condemned by Pliny (*Nat. Hist.* XXXV 4). By the third century AD garments had become shorter and the toga draped in a different fashion with the closer fitting *contabulatio*, a pleat around the chest; but even though the legs were now partly shown, there is little feeling of a body inside the folds of cloth. When portraits originate from provincial cities they may show indications of local styles as well as a desire to prove how 'Roman' the subject was. The numerous inscribed bases found in these provincial sites show how many statues were erected to honour local benefactors and leading citizens.

In statues of women at all periods there is more attempt to explore the underlying figure, most noticeably in the swathed *pudicitia*, or modesty, pose of figures like Eumachia, benefactress of Pompeii, but also beneath the looser draperies, cf. the Vestal Virgins in the forum. It is not always possible to tell whether these statues are portraits or types of the modest woman to be contrasted with a Venus-style figure in a fountain or sepulchral group. The appreciation of the completely swathed figure can be seen in the charming statue of a young woman (Fig. 1.1). The pattern of contrasting folds that cross the limbs are enhanced by traces of pale blue and yellow in the pleats of her red-bordered cloak. Even her hands are tightly wrapped and this total veiling draws attention to the one uncovered feature, her serene face. There are some exceptions in portraits when the focus is more on the female figure than the head, as when members of the imperial families are shown nude in Greek poses as Venus or the astonishing statue in gauzy draperies that bears the head of Sabina, wife of Hadrian. Most frequently, women are respectably dressed in the long Roman dress, *stola*, or the Greek version, *chiton*, and a wrap, with only the looseness of the neckline to suggest their charms, and in general the effect is columnar.

Portrait Busts

This rather uninteresting treatment of the figure, both male and female, focuses attention on the face, and it is the portrait head that reveals most about what the republican Romans wanted in a likeness. In the Republic in the style known as Verism, details of appearance were carefully reproduced or even exaggerated. Some attribute this to the *ius imaginis*

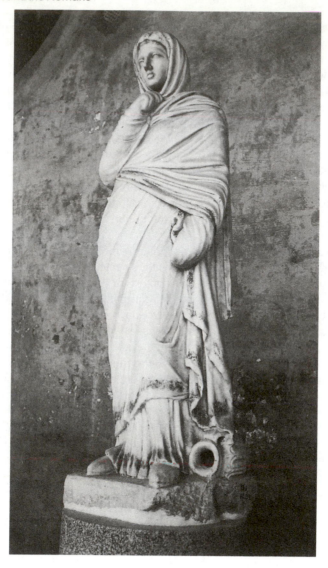

Fig. 1.1 Young woman in the *pudicitia* pose with traces of original colour; despite the *contra posto* stance there is little attempt to convey the body beneath the robes.

of noble families mentioned above. This skilful rendering of leathery skin and sunken cheeks, furrowed brows and deep set eyes, shows that sculptors appreciated the structure of bones and muscles, though the prominence of the bridge of the nose and the deepened furrows from nose to mouth can sometimes make a portrait more deathlike than lifelike. Emphasis on prominent features might also serve to confirm relationships

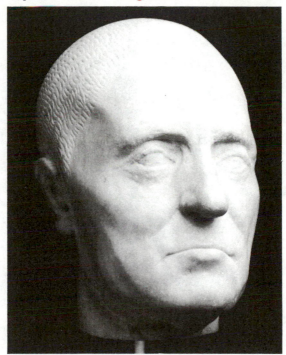

Fig. 1.2 Bust of older man, 30-60 BC. Peck marks indicating his scant hair and his sunken cheeks recall the tradition of death mask portraits.

where belonging to the right family could influence your political future. The countless heads of wrinkled, balding senators and local magistrates, who look straight ahead with an unflinching expression, seem to embody the republican qualities of *auctoritas*, *gravitas* and *dignitas* (authority, serious-mindedness and dignity) that were looked for in the education of the period. The hair is suggested by little more than incised lines and the level open gaze is emphasised for today's viewer by the blank eyes, as little, if any, of the original colouring survives (Fig. 1.2). The set of the eyes below the brow nevertheless does much to convey intelligence and concentration. There is no attempt to flatter; necks are wrinkled and

ageing and jaw lines sag. In early portraits even the surface texture adds to the impression of toughness given by the firm mouths. These forth-right, no-nonsense portraits were intended to sum up the looks, career and character of men of a period when age and experience were valued above physical beauty.

The same treatment can be seen on the grave steles, where freedmen

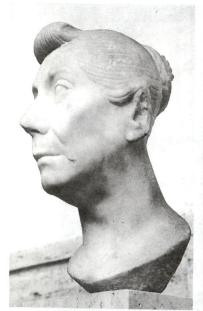 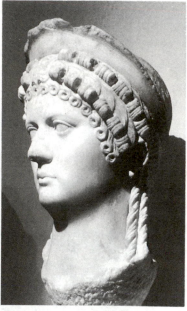

Fig. 1.3 a) Bust of older woman c. 43 BC; the flat treatment of her hair accentuates her drawn face; b) idealising portrait of a princess in classical style, 1st century AD.

too wished to record their likenesses and achievements. These were sited along the roadside outside the city walls and the framed faces of the departed, often in family groups, gazed out at passers-by. Even when they are later in date these portraits in high relief are republican in style, asserting the Roman status of these former slaves, whatever their origins. Men are shown with close cropped hair and women with the traditional *nodus*, the roll on the forehead carried back as a plait (Fig. 1.3), or both may follow imperial styles; fuller hair for the men and crimped waves for women. So consistent was the style that sculptors made up steles in advance with an egg-like head only roughed in awaiting a commission. *Busta*, a tomb, is in fact the origin of the term bust. These stele portraits

mean us to know how seriously the subjects took themselves and their pride in the status they had achieved. Some have indications of their business or social importance carved alongside – a corn measure or the *sistrum*, sacred rattle of a priest of Isis – and all have a look of such reality that they must have been easily recognisable.

Noble families were the first to follow the imperial family in adopting

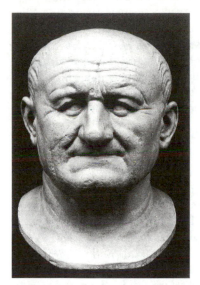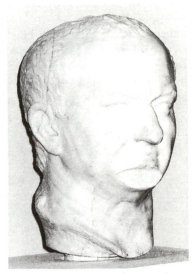

Fig.1.4 a) Vespasian, the Veristic treatment, cast of Copenhagen bust, contrasted with b) the official image of Vespasian, the emperor.

classical models for their portrait busts; these tended to give a tilt to the head and a more tactile surface with greater emphasis on the hair. With the introduction of Carrera marble in Augustan times a more polished finish is apparent and in private portraits *gravitas* begins to give way to a desire for grace and idealism. Compare the two busts in Fig. 1.3: the realism of the republican portrait of the older woman whose drawn face is accentuated by the flat treatment of her hair contrasts with the idealised status portrait of a young woman of the imperial court which is reminiscent of an air-brushed studio photograph. A form of Verism, interest in the real appearance of the subject, did return and existed side by side with the idealised; this can be appreciated by looking at the frank, family likenesses of Claudius or Vespasian beside their official imperial images; notice the toothless, humorous expression of the private man whose country background and earthy humour the historian Suetonius describes

(*Vespasian* 1.2,22) and the stern gaze of the Emperor (Fig. 1.4). Some-times this style verges on caricature in portraits with beetling brows and sagging neck, but it may reflect the same sort of desire to conjure up a physical presence that prompted the sculptor to portray Caecilius Iucun-dus of Pompeii literally with warts and all. Already by mid-first century, portrait busts, even imaginary portraits of Greek poets and philosophers, had become prized as works of art rather than a record and Pliny condemns those who preferred to 'leave behind portraits of their wealth rather than a true likeness of themselves' (*Nat.Hist.* XXXV 5). There were periods when there may have been a political reason for this; in Rome a successful man might be reluctant to commemorate his achieve-ments and bring down the wrath of a suspicious emperor. The fate of the ambitious Sejanus and of his statues at the hands of Tiberius were sufficient warning.

> The bronze statues are roped and down they come. Then the axe fells the chariot wheels and the poor old horses' legs are smashed. Now the fires roar and the head of mighty Sejanus, the idol of the mob, burns and crackles in the furnace. Then the face that was second in the world a moment ago is melted down to make water cans, basins, frying pans and chamber pots.
>
> (JUVENAL, *Satire* X 56ff.)

Hadrian's love for all things Greek set the fashion for portraits in the Greek manner and the introduction of the use of the drill made greater chiaroscuro possible, enhancing or even exaggerating some features. Nostrils and ears are more deeply cut, so is the mouth, with the result that the lips appear about to part and there is great emphasis on deeply drilled or under-cut curling hair in swirling locks. From the first century AD the bust tended to be deeper which allowed a more expressive turn of the head. Artists began to carve the eye in more detail instead of relying solely on colour. This indication of the direction of the gaze with the increased use of the turned head pose enabled sculptors to produce revealing character studies, showing the disdainful, preoccupied or sus-picious nature of the subject. There was also a greater interest in contrast of surfaces between textured and polished. The skin seems to have a soft surface with real wrinkles. Imperial fashions influenced the length of hair and beard all over the empire; the portrait heads from the villa at Lullingstone, Kent, resemble the emperor Septimus Severus (AD 193-211) in style. Women continued to be shown with calm expressions though there are some revealing portraits of older women, but the interest

is mostly focused on the hair, crimped waves, rows of drilled kiss curls, towering edifices of curled hair-pieces and elaborate buns – even wigs. The likenesses of small children were also recorded, usually at the chubby and charming age, so that it is difficult to detect how much their characters are conveyed.

Imperial Portraits

The Romans were very conscious of the value of art for political ends whether in depicting national heroes to glorify Rome or in erecting a statue to glorify an emperor. On assuming power the Dictator Sulla had all the statues of Marius removed and in later times the *damnatio memoriae* of an unpopular politician or emperor meant above all the destruction of his statues. It was under Augustus that a full programme of art to support the regime was realised, entailing not only portraits but reliefs and the decoration of public buildings. It was important that the peoples of the Empire should know what their ruler looked like and pronounced features, such as the far-sighted gaze and the locks on the brow of Augustus or the bull neck and side whiskers of Nero, were emphasised in portraits, gems and coins. (Although a study of coinage is outside the scope of this book, it will be found that much the same styles of portraiture apply.)

Portraits of Augustus move away from republican realism to a neo-classical style to create an inspirational figure. Statues of triumphant generals were already familiar, but none so packed with political messages as the statue from Prima Porta, now in the Vatican Museum. Using the heroic pose and ideal proportions of Polycleitus' Doryphorus the artist, probably Greek, shows Augustus barefoot as befits a hero, with Cupid at his side to stress his Julian descent from Venus via Aeneas. His elaborate breastplate with sphinxes on the shoulders that recall his annexation of Egypt is embossed with images giving political messages. In the centre it shows Tiberius receiving the Roman standards, lost at Carrhae, from a trousered Parthian. The sky spreads protection above and earth pours out plenty below while Apollo, Augustus' guardian deity, and his sister Diana look on with approval. The image of a victorious general is not inappropriate to Augustus who restored peace to Rome after fifty years of intermittent civil war, even though he had not been a great general and it was Tiberius who had in fact recovered the standards from the Parthians without warfare. The image was what mattered, just as to those who lived through the Second World War the craggy figure of Ivor Roberts-Jones' Winston Churchill in Parliament

Square, London, embodied victory more successfully than any statues commemorating the generals who won the battles. Augustus continued the extension of the Forum area begun by Julius Caesar, adding a Forum of his own to the NE of the Forum of Julius. He adopted the classical styles of fifth-century Greece, referred to as neo-Attic, where figures were based on the ideal proportions of works by Polycleitus and Lysippus. The golden age of Greece was being used to express the golden age of Rome. In this forum he placed statues of legendary and historical heroes from the early days of Rome and a temple to Mars, linked with Rome as the father of Romulus and to Augustus by his association with Venus. Augustus' own statue stood in the centre making a claim through these associations expressed in sculpture to be considered as the second founder of Rome. Similarly in the parade of heroes in the underworld Virgil had placed him between Romulus and Numa, the first and second kings of Rome (*Aeneid* VI 777-810). The togate statue of Augustus from the Via Labicana shows him as the *pius*, peace-bringing father of his people (Fig. 1.5). His outstretched arm probably held a libation bowl, *phiale*, to complete the impression. The features, the characteristic locks above the firm brow are a repeat of those of the previous statue, and this was to remain the image of Augustus throughout his life. Princes of the Julio-Claudian family were so uniformly shown in similar manner that identification is often difficult. The republican concept of the wisdom of experience shown by an ageing portrait had been changed for the godlike.

Augustus however was not personally responsible for the erection of all the statues in his honour – about 300 of them survive – or in honour of his wife Livia or his grandsons. Often it was local benefactors or the *Augustales*, the priests of the imperial cult, who had statues set up in towns and cities throughout the empire. The idea of a ruler being considered as a god is alien to our way of thought, but it had been common in the Hellenistic world. In Roman mythology too there were men like Hercules and Romulus who had become gods through their great achievements. In *Eclogue* I.6 Virgil's shepherd declares that the man who has restored peace must be a god and Horace begs Augustus not to be in too great a hurry to return to heaven (*Odes* I.ii.45ff.). It is not so surprising therefore to find statues erected to emperors showing them in the guise of gods. L.M.Seneca, a soldier of the XIIIth Urban Cohort, set up two nude statues of Augustus and Claudius with the sceptre and thunderbolt of Jupiter in the basilica of Herculaneum. In Leptis Magna, Libya, a dedication by the proconsul and his legate shows both emperors as Jupiter seated in a half-turned pose,. There are not many nude statues of individuals under the Republic, as nudity was regarded as an attribute

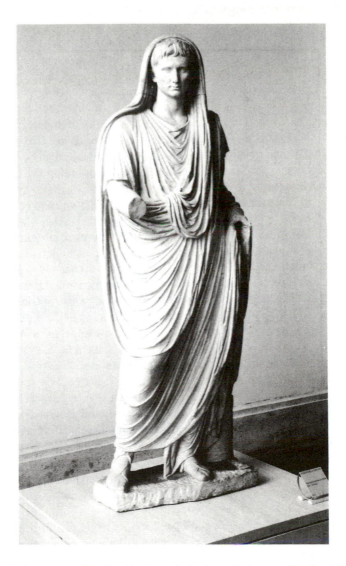

Fig. 1.5 Augustus as Pontifex Maximus; the locks on his brow and the far-sighted gaze remained part of his official image for life.

of gods and heroes, but nude statues of emperors are comparatively common, generally showing them wearing the oak garland of the *corona civica*, the award for courage that had become a symbol of emperorship, or with the attributes of Jupiter. A relief from the Sebasteion at Aphrodisias in Turkey shows a naked Claudius subjugating a female personification of Britannia. Such portraits can be interpreted as a symbol of what an emperor might become or as a desire by the Romans for the protection of a divine guardian or, in the Eastern empire, as following the Hellenistic tradition of divine rulers. As works of art they are not always successful: the homely features of Tiberius or Claudius sit somewhat incongruously on the heroic muscular bodies of nude statues. Whether the imperial portraits erected by loyal or ambitious subjects were statues or busts, in public places or in their homes, the cost of them was considerable and several heads of emperors exist which have clearly been reworked to give them the features of their successors. Caligula's cast of feature does not wholly disappear when reworked as Claudius. In Vaison-la-Romaine, Provence, there is an all-purpose imperial statue in military dress which seems to have had the head changed with each successive emperor; it currently bears the head of Domitian. However as the first century AD progressed there was a growing identification of the emperor with his portrait and we read of supplication being made to the statue of the emperor. At the end of Corbulo's campaign in Armenia Tiridates makes his submission by laying his diadem before the effigy of Nero, placed in the curule chair (TACITUS, *Annals* XV 29).

When Hadrian became emperor in AD 117, his passion for Greek culture made a great impact on Roman art and began a classical revival. Nicknamed Graeculus he employed Greek artists and decorated his villa at Tivoli in Greek style. Hadrian also had one significant effect on Roman portraiture – the beard. In the previous century beards had been worn only by young men under twenty four, whereas in classical Greece they had been the mark of the statesman, poet or philosopher. Hadrian and his immediate successors are usually shown in military dress with beards and curly hair deeply worked with a drill. Hadrian's portraits progress from a youthful, neatly clipped beard and hairstyle to full beard and longer curls. Antoninus, Marcus Aurelius, Commmodus and Septimius Severus are all portrayed in similar style as though curls and flowing beards were the badge of emperorship. Portraits of Marcus Aurelius may change from godlike youth to grave emperor with worried eyes, but the luxuriant curls remain the same and the beard follows the philosopher tradition. In the well-known bust of Commodus as Hercules, the chiaroscuro of the deeply drilled hair and beard contrasting with the polished

muscular torso, and the framing lion's mask contrasting with the emperor's harmless expression, make for an unusual image. Severus employed Syrian artists who followed Eastern Mediterranean traditions and seem to have borrowed the beard of the Egyptian god Serapis for the emperor. In portraits of Caracalla the beard is less strongly shown and the emphasis is on ferocity of expression, so that by the time of the portraits of Maximinus Thrax and Philip the Arab beards have become little more than designer stubble and the hair a close cap. These images of campaigning generals appealed in a tough age and the workmanship reflects the mood.

A surprising feature of imperial portraits is the degree of frankness apparent in many of them. Studying the faces of Caligula, Nero or Caracalla we get an insight into their characters and certainly Commodus' vanity did not escape the artist. The portraits of the emperors, just as much as those of private citizens are of individuals and not of types. It is in the third century AD that the expressions of the later emperors become stern and impersonal with staring eyes until, seeing the colossal heads of Constantine, we realise that it is the office rather than the man that is being recorded.

Painted Portraits

A true appreciation of painted portraits is made difficult by the limited numbers that survive. We are told that at one time portraits were painted on wooden panels, but by the end of the republic painting really meant wall-painting. Some of the paintings from Pompeii and Herculaneum in the style that depicted painted versions of the walls of wealthy houses show busts in circular frames which may represent an early form of portrait, the *imago clipeata*. These were heads embossed on circular shields used in religious rites and also hung as wall decorations. These are usually small and not true portraits so much as suggestions of the status of the family. There are several paintings at the focal point of plain coloured sections of wall that might qualify as portraits at first sight but these are generalised faces of gods or heroes achieved with bold brush strokes. Of the few true portraits two of the most familiar represent two styles. In a circular frame a young girl with wax tablets in hand and her *stilus* to her lips gazes out in apparent reverie. She has much in common with the idealised court ladies of the mid-first century AD and it is interesting to compare the painted version of the kiss curls below her gold net cap with the neat rows on sculptured brows. She does not seem to be very individualised and it has been suggested that she represents a

poetess, perhaps Sappho. However the tablets and *stilus* may just be a claim to good education, as they figure in the other famous portrait of a man and wife. In contrast this pair are far from idealised and their features are somewhat irregular. The play of light on their noses, foreheads and cheekbones conveys their glistening skin and her wispy curls and his straggling beard and moustache are drawn in fine dark strokes. It is hard to be sure whether other paintings of heads are individuals or mythological figures or imaginary likenesses of Greek poets and philosophers. Common to all are the large, wide-open eyes and rather heavy eyebrows.

The same wide-eyed gaze marks another group of portraits which date from the first and second centuries AD and were preserved in the sands of Egypt, particularly in the Fayum area. Painted on thin panels of wood in tempera or encaustic, these portraits are of Greeks whose way of life and death combined elements of Roman and Egyptian culture as well as Greek. Their funerary rites derived from the Egyptian and these panels were inserted into the mummy coverings or shrouds of the dead, so that they appear to be looking out at us from the wrappings (Fig. 6.1 p. 76). The portraits are in the Roman convention of the busts that imitated the imperial dress and hairstyles, yet they manage to be extremely lifelike and direct as well. In the tempera portraits the pigments are mixed with water-soluble agents and painted on a white or pale-coloured ground. A fine brush is used for exact detail and shading. Encaustic paintings mean that the colours have been mixed with malleable wax by various methods and produce portraits somewhat akin to oil paintings. Generally the head is slightly turned and the contours of the face defined by use of colour and shading. Details of jewellery and dress are clear and the features so expressive that they seem like people we have always known.

Chapter 2
Sculpture

Statuary

Sculpture and the Gods

Most ancient peoples wished to make statues of their gods. The Romans, however, originally conceived their gods as *numina*, powers that had no need of images, and the idea of the cult statue came to Rome from the Etruscans and other conquered peoples, whose gods they also captured. In V.22 Livy has a lively account of how the Etruscan statue of Juno, nodding her assent to the soldiers, was brought from Veii to Rome. Much of Etruscan sculpture was in terracotta, and more of this survives than of their remarkable achievements in bronze, always vulnerable for its scrap value. In the early Republic the Romans too worked in terracotta when creating pedimental groups for temples or images of the gods, replacing them with bronze from the third century BC. These images were somehow conceived as acting for the gods and were brought out of their temples to watch a triumph pass or couches were laid for them at the banquet festivals of the *lectisternia*, celebrated in times of crisis. As the influence of the Greek cities of Southern Italy and then of the mainland increased there was a great growth of art at Rome, and Greek artists were commissioned to supply statues of Roman gods. This led to subtle changes in the character of the gods themselves as they took on the attributes of the Greek gods with whom they were increasingly identified. In 133 BC King Attalus III of the wealthy and artistically rich city of Pergamum willed his kingdom to Rome, with the result that the vigorous tradition of Pergamene carvings was another influence on Roman religious sculpture.

Only a few statues that are known to have been in temples have survived the adoption of Christianity from AD 380 onwards. Some of the most remarkable are the figures of Aphrodite and Artemis – as goddesses of fertility – from Aphrodisias in Asia Minor where there was a productive school of sculpture. There are large numbers of smaller statuettes in bronze and terracotta, as these were made both for household shrines and for the votive offerings, which Romans would promise to donate if a

prayer was answered. These often reproduce the poses of the cult statues in major centres of worship and illustrate their debt to Greek art, but as they tend to be mass-produced they lack detail and cannot show us the grandeur of the temple statues.

The religious revival engineered by Augustus entailed the introduction of new statues of the gods in neo-Attic style. By drawing on the style of fifth-century Athens, the emperor hoped to suggest to his contemporary Romans that the achievements of their age matched those of the age of Pericles. In 2 BC in an interesting antithesis to the Ara Pacis, the Altar of Peace, Augustus dedicated an enormous statue of Mars the Avenger, shown as a mature protector of his people. His temple, where the standards recovered from the Parthians were stored, was the focal point of the forum of Augustus, mentioned earlier. The poet Ovid describes this forum, which also contained statues of Romulus and Aeneas with whose role as founders of Rome Augustus was intended to be associated (*Fasti* V 549 ff.). Augustus had a particular devotion to Apollo to whom he attributed his success over Antony at Actium and had already built a temple in his honour, adjoining his own house on the Palatine. The statue was 'fairer than the god himself', the poet Propertius tells us in a poem to Cynthia ostensibly excusing his late arrival because he has been to the dedication of this temple of Apollo (*Elegies* II 31). The Romans had always tended to deify abstractions such as Concordia and Fortuna, and Augustus too used benificent images of Roma and Italia to enhance his own. He also set up a statue of Victoria outside the Curia to which daily sacrifice was made.

How far Augustus succeeded in carrying with him the thinking of the nobility of his time is debatable. When original Greek statues of the gods had been brought to Rome, though there are some records of their being dedicated in temples, they were often perceived as works of art rather than objects of worship. Statues of Venus were appreciated as the embodiment of feminine beauty and Apollo or Dionysus as the ideal of young manhood. Pliny the Elder records that works by the Greek masters Praxiteles, Skopas and Leochares were on show in public galleries and temples, and there was a tradition of the public dedication of sculpture by victorious generals to demonstrate wealth and power. On the other hand Verres, in his notorious plundering of the shrines of Sicily during his governorship, was certainly not motivated by their religious value. Cicero, who led the indictment against Verres, was himself a collector of Greek sculpture and writes repeatedly to Atticus to send him statues from Athens to adorn his villa at Tusculum. He emphasises his enthusiasm for art yet leaves the choice to his friend, as he would 'know what

was suitable' (*Ad Atticum* 1.8). This appropriateness of works of art was a common feature of Roman taste – a Minerva or a philosopher for a library, a hero or an athlete for a gymnasium – and Greek originals were eagerly sought after. There was a flourishing art market in Rome, and at the end of the first century BC Augustus' minister, Agrippa, expressed the surprisingly modern view that great works of art should not be in private ownership. This would have been better than banishing them to country houses, comments Pliny the Elder (*Nat Hist.* XXXIV 279).

There were religious statues that were not of the Olympians but of local cult deities and these might include mortals regarded as heroes by their family after their death. The Emperor Hadrian commissioned statues of his favourite Antinous in the guise of Dionysus or Silvanus. When Antinous died Hadrian commanded his veneration in shrines throughout the empire and there are numerous statues showing him as the ideal of youthful beauty (Fig. 2.1). In his enthusiasm for Greece he also employed Greek sculptors to copy or create classical-style statues for the public buildings he had erected in Athens, Jerash, Ephesus and Egypt as well as for the imperial villa at Tivoli. There he had built a replica of the temple of Aphrodite at Cnidos, with a copy of the statue by Praxiteles, and many of the most important sculptures in the great collections will be found, when one reads the labels, to have come from Tivoli. He was equally interested in relief sculpture, as we shall see later. It is as a connoisseur of art rather than the builder of a wall in a remote province that he would have wished to be remembered.

Originals and Copies

In the Republic victorious generals dedicated much of the original sculpture they brought back as booty to be put on show in temples or public buildings. After the defeat of Syracuse in 211 BC, Marcellus set up so much Greek statuary in the temples at Porta Capena that according to Livy they became a tourist attraction (*Histories* XXV 40). Under the empire wealthy Romans would often purchase works of art to be put on public display, partly it must be said as a form of self-advertisement. A revealing letter from Pliny the Younger tells us how this was done and also how much store was set on acquiring a piece with a good provenance; Corinthian bronzes were much sought after. It is also interesting to note the realistic features that attracted Pliny to the piece and his disclaimers of any artistic expertise.

> From an unexpected legacy I have just bought a Corinthian statue, only small but pleasing and realistically rendered as far

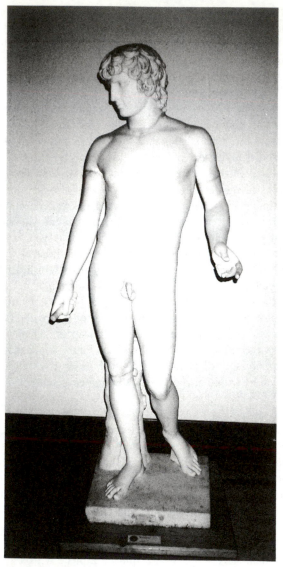

Fig 2.1 Antinous idealised as a Greek *ephebe*; one of many statues commemorating Hadrian's favourite.

as I can judge – and I am poor judge of such matters, as perhaps of everything. However I think I can appreciate this statue. It is naked so that its faults, if any, as well as its virtues are open to view. It is the figure of a standing old man with lifelike bones, muscles, sinews, veins and wrinkles. The thin hair is receding, the brow broad, the face shrunken, the neck thin, the arms feeble and the chest and belly hollow; the back gives the same impression of age as the front. The patina of the bronze and the remains of the original colour indicate that it is a genuine antique. In fact it has everything to attract the eye of artists and delight the non-expert. I did not buy it to have it at home (for I have not got any Corinthian bronzes yet) but to put in a public place in my home town, preferably in the temple of Jupiter.

(PLINY, *Letters* III.6.)

Pliny goes on to ask his correspondent to have a base made for the statue and to have his name and, 'if he thinks proper', the list of his official positions inscribed on it. It is clear that anonymous benefactions were not part of Roman life and just as public buildings (such as the theatre in Pompeii) bore inscriptions naming the donor, so too did pieces of sculpture. The taste for exaggerated realism was not confined to Pliny and there survive other statues of the type he chose. In the Museo Nazionale in Rome there is a bronze of a battered boxer with over-developed muscles, bruised and swollen face all faithfully modelled and his cuts picked out in copper. A similar interest in depicting physical detail is apparent in the crouching bronze of a drunken old woman cradling a wine jar and the sagging figure of an old fisherman.

This admiration of all things Greek led to a huge demand for copies of well known Greek and Hellenistic works. In the first century BC Pasiteles, a Romano-Greek, probably from Southern Italy, founded a school of sculpture at Rome which produced works similar to the 'severe style' of fifth-century Athens. The Orestes and Electra group in the Naples Archaeological Museum is an outstanding example of their work; the tilt of Electra's head gives the touch of sentiment which Romans preferred. This is a feature that can often be seen in Roman versions of classical originals. There were also schools of sculpture in Rhodes and Asia Minor producing original works and variations of classical subjects as private commissions for wealthy Romans, and in even greater numbers for the decoration of temples, libraries, basilicas and porticoes. The facade of a public building or the *skene* wall of a theatre was built with architectural niches designed to contain statues, and for these the same

works were copied over and over again. The greatest demand was for copies of famous statues by Pheidias, Polycleitus, Myron, Praxiteles, Skopas and Lysippus. The readiness with which a part-draped female figure, even, or particularly, when armless, is acclaimed as Venus is a comment on how many versions of these popular statues were made. So many copies of the Greek and Hellenistic originals exist that they are referred to by terms such as Crouching Venus, often based on the kneeling figure by Diodalus of Bithynia, or Venus, Modest Rhodian type. Often these have had heads and arms restored to fill the latter-day demand for classical statuary in the eighteenth and nineteenth century. The more mature pose of Venus Genetrix, a popular image as mother of Aeneas and thus protectress of the Julian Gens, was copied for portrait statues. These Graeco-Roman artists supplied the copies or versions thought suitable for the setting – Nereids for the *nymphaeum* or fountain house, Artemis accompanied by hounds for a country villa. To fit a particular position copies were often reduced in scale or made in pairs, with the pose reversed for symmetrical arrangements, and details might be changed to provide balance. On the obverse of coins we can see temples with statues in complementary pairs placed between the pillars of the *pronaos*, or front portico, and flanking the steps. Bases which remain on sites throughout the empire from Jerash to Dougga provide evidence for the placing of statues in public spaces in numbers that today would probably seem excessive and more obstruction than ornament, but they would certainly have given an impression of wealth and magnificence.

The extravagant poses of the Hellenistic sculptures that adorned the monument of Attalus I of Pergamum, the dying Gaul or Galata in the act of suicide, were much admired and at least one marble copy came to Rome in the first century BC, possibly to celebrate Julius Caesar's conquest of the Gauls. Similar groups, often depicting dramatic moments of a life and death struggle, were thought suitable for adorning the palaces of emperors or the massive public buildings of the second and third centuries AD. Hellenistic schools of sculpture existed in centres such as Aphrodisias and Rhodes, and it was in Asia Minor that these monumental groups of figures in a style sometimes called Hellenistic Baroque were produced. Opinions differ as to whether the well known example of such groups, Laocoon and his sons struggling with the snakes from the palace of Titus, is Hellenistic or a Roman copy, but it illustrates some of the features of such work. Deeply drilled to produce striking chiaroscuro, the contorted figures have wild unkempt hair, open mouths and agonised expressions. The huge group of Dirce and the bull must have dominated even the vast space of the Baths of Caracalla, but Roman taste enjoyed

size as a reflection of power and glory. Romans also appreciated cleverness and therefore the skill required to render complex poses and extreme emotion, just as they appreciated the poetic skill and vividness in descriptions of such scenes in Ovid. Scenes of suffering and violence may seem to us tasteless subjects for decorative schemes, but we have to remember many Romans also enjoyed all the forms of killing at the Games in the arena.

Copyists had no hesitation in making changes from the original in a version. The attributes carried by a god in the original might be altered to suit the proposed setting, or, as we have seen, the head given the features of an emperor. Comparison of various versions of an original shows how much these could differ. A mature Aphrodite had been created by a Greek artist c. 420 BC and from this the neo-Attic sculptor, Arkesilaos, had derived the Venus Genetrix for the temple of Venus in Caesar's forum. Many copies were made, some reversing the pose. The version in the Louvre has a tender expression, her head inclined to look, as it were, towards the recipient of the fruit in her outstretched left hand (Fig. 2.2a). Another version in Holkham Hall has a longer neck, her gaze is directed beyond us and her down-turned left hand holds a jug. These changes make her a cooler, more majestic figure but she does not engage with the viewer (Fig. 2.2b). This frequent copying explains some of the criticism made of Roman sculpture. Copies tend to get progressively further from the original. Marble copies of bronzes were cheaper but lack the life of the original and required struts and props which spoil the outline, even when disguised as an appropriate accompaniment to the figure. Destined for display in an architectural setting, such sculptures were meant to be seen from a single viewpoint and so a strut could be made less obvious. For the same reason there are statues, as may be seen in Leptis Magna, where the back has been barely worked at all. Today, seen free-standing, these can be criticised for lack of skill, but were really designed for display in a particular location.

In the eighteenth century there was a similar demand for classical statues by wealthy European collectors to satisfy which the treasure hunting forerunners of archaeologists supplied missing limbs or features to the statues that were being discovered. This over-zealous restoration has sometimes distorted the original composition. English country-house collections contain many such 'classical' statues, which have limbs restored or heads from other works added. A version of Myron's discus-thrower, now at Bowood House, has been misunderstood and transformed into Diomedes carrying off the Palladium, which makes no sense of the freeze-frame pose of the athlete. However, the numerous copies

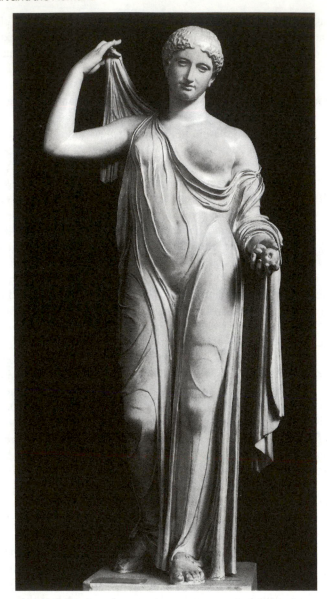

Fig 2.2 Two versions of Arkesilaos' Venus Genetrix:
a) Copy of the Louvre version seems to offer her fruit to the viewer.

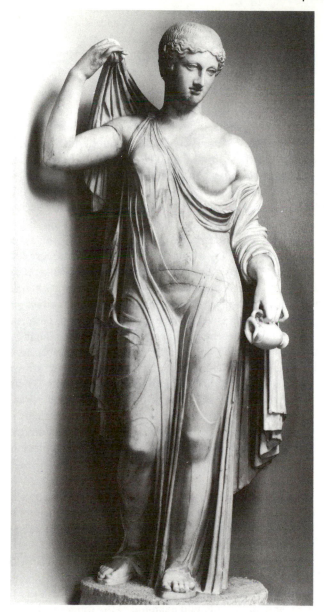

Fig 2.2 b) The Venus Genetrix from Holkham Hall is more
distant and majestic.

or versions of Greek works not only give us some idea of lost Greek originals, but also sparked the neo-classical movement, as examples came to light with the excavation of Pompeii and Herculaneum in the eighteenth century, inspiring sculptors like Canova and John Gibson.

Private Taste

The Romans who spent their days amid the public splendour of basilica, temple and colonnade soon wanted the same kind of *luxuria* in their homes as well as their cities. Copies of famous Greek and Hellenistic originals were made, often on a smaller scale, to fit the decorative scheme of a villa. Small versions of famous works were displayed on sideboards and sometimes adapted to hold lamps. Even Cordus, the impoverished scholar in Juvenal's *Satire* III, owned a bust of Chiron, the teacher of the heroes. Philosophy had replaced personal religion for many educated Romans by the first century AD and busts of philosophers were supplied in large numbers, their high, lined brows and luxuriant beards recognisable even when they are unnamed. Greek and Hellenistic artists had produced likenesses, often imaginary, of Athenian statesmen and Greek poets and philosophers, and these were reinterpreted for Roman patrons. In fact patrons seem to have been not too concerned about naming the philosopher's likeness they had obtained to suit their own persuasion. Others would choose literary figures and about fifty copies are known of the bust of Menander by the sons of Praxiteles, for example. The range of copies of Greek works, excavated from the Villa of the Papyri near Herculaneum and now in the Naples Museum, shows how richly the villas of the wealthy were decorated. So lavish were the collections of the rich that, according to Juvenal, they could easily help each other refurnish after a fire:

> Even while the house is still burning, someone runs up to donate marble, another contributes to the expenses; one friend offers some famous work by Euphranor or Polyclitus, someone else the trappings from Asian temples.
>
> (JUVENAL, *Satires* III 215ff.)

Gardens too were lined with statues and Hadrian's Villa at Tivoli provides a particularly splendid example of the fondness for combining sculpture and water: copies of the caryatids from the Athenian Acropolis stand beside a long pool. Versions of the weary Hercules of Lysippus and similar figures were popular, the Romans taking pleasure in the

heavy musculature and somewhat mocking representations of the hero. Bacchic subjects, a satyr twisting to look at his own tail, a sleeping faun, drunken Silenus, followed Hellenistic versions. Half-turned and delicately poised, their poses were made possible by the support of accompanying hounds, or vine-laden stumps. In the House of the Marine Venus, Pompeii, on the rear wall of the courtyard is painted a garden with a view of the sea on which floats Venus in a shell. To give added point, a statue of her lover, Mars, is painted to the side among shrubs – an example of the type of effect desired even in smaller properties. Some garden and fountain statues seem rather sentimental – small slaves falling asleep over lanterns or spilt urns, and Cupids struggling with geese or dolphins – but the poses are skilfully realised and copies are still purchased today. Equally frequent in gardens were sculptures of animals. These are extremely lifelike as can be seen in gardens in Herculaneum, or in the gallery devoted to animal sculptures in the Vatican Museum. Again, we see the Romans' brutal streak and struggles between different animals appear to have been thought a particularly suitable subject for gardens. There is a story that Prasiteles used to go to the docks to sketch the animals imported for the Games. Whether in bronze or marble the creatures show that sculptors had an interest in rendering surface textures and a good knowledge of anatomy, particularly when the animal is shown in motion or fighting;

Relief Sculpture

Sculpture in relief does not present the same problem of support. It also makes possible the representation of detailed and complex scenes – and in this Roman reliefs excel. Greek reliefs had concentrated on bold shapes with a strong overall design. Background is absent or minimal and the number of figures limited. Early reliefs such as the scenes of legendary Roman history on the frieze of the Basilica Aemilia have vigorous movement in the Hellenistic manner, with Romans pursuing the Sabine women or punishing Tarpeia. However, Romans really preferred to record in accurate detail and this is apparent in reliefs of every kind from altars to funerary monuments and from shop signs to sarcophagi. At every period scenes of public sacrifice were shown as they indicated a god-fearing character. They make an interesting comparison: a frieze from the first century BC, now in the Louvre, treats it in processional manner with temple slaves marshalling the pig, sheep and bull for the *suovetaurilia*, the solemn occasion when all three were sacrificed. A century later an altar in Pompeii shows a more composed scene (Fig. 2.3a)

with figures two or three deep and the garlanded temple in the background. On the front of the stage in Sabratha dating from the second century AD the dumpy figures of the celebrants are lined up round the altar in entirely static pose, facing front, because at this period it was important to record just who was present. In the time of Diocletian a sacrificial procession, in the manner of first century BC but in shallower relief, was carved on the base of a column in the forum (Fig. 2.3b).

Scenes from daily life such as a farmer going to market, boys at school, interiors of shops, actors and gladiators were carved on funeral monuments, on shops and theatres, while public buildings were frequently decorated with records of public events. Some are historical like the crowded battle scenes on the monument of the Iulii (two grandsons of Augustus) at St Remy in Provence, which recall one of the common themes on Etruscan ash chests. Many illustrate public occasions like the census-taking or the procession of the *vicomagistri* (local officials) to a sacrifice. To the emperors reliefs were a graphic way to show the power and prosperity of Rome under their leadership.

Imperial Reliefs

In 9 BC the Ara Pacis, an altar within a walled enclosure, was dedicated in celebration of Augustus' restoration of peace. On the walls were large relief panels with images full of propaganda messages but not of military victory. Along each side is a procession of priests and the imperial family with Augustus, his head piously veiled, but shown at the same time as a family man with heirs to succeed him. His programme of revival of religious observance and family life was thus silently conveyed in sculpture. These two friezes are Greek in style and show a double rank of figures. The vertical lines of their draperies are saved from monotony by the smaller figures of the children and by differences in the drape of togas and of gesture. To give an impression of depth the second rank of figures are in lower relief and this technique was used repeatedly for the next century for complex scenes. On the front of the enclosure a pair of panels show Aeneas and the Penates and Romulus and Remus, associating Augustus with the early history of Rome and suggesting his claim to be regarded as another founder. The back panels show allegorical figures, Roma and Tellus, mother earth (Fig. 2.4). The Romans were fond of such personifications and this satisfying composition of the gracious figure with infants on her lap, surrounded by plants and animals and flanked by nymphs, suggests that Augustus has brought a return of the Golden Age and recalls the idyllic picture of Italian country life conveyed by Horace

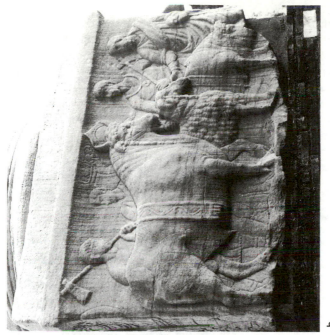

b

a

Fig 2.3 a) Scene of sacrifice on the altar of the Temple of Vespasian, Pompeii, c. AD 70, with figures realistically grouped. b) Sacrificial *suovetaurilia* procession in the manner of 1st century BC, though erected AD 303. From the base of Decennalia column, Forum, Rome.

and Virgil. These ideas are further emphasised by the exuberant decoration of all the other outside surfaces with delicately cut acanthus and scroll patterns, while garlands and swags decorate the inner faces. These motifs were soon being used on both private and public works as well as personifications and mythological figures with symbolic meanings. These reliefs on the Ara Pacis are remarkable for their lack of triumphalism; after Augustus most imperial reliefs have themes of triumph and authority and are displayed on civic rather than religious buildings.

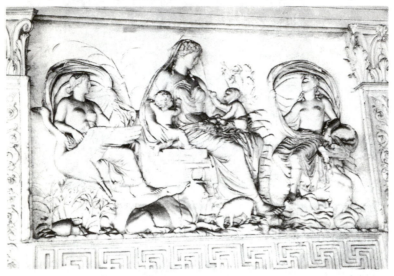

Fig 2.4 Tellus from the Ara Pacis, Rome, symbolising the peace and plenty of Italy under Augustus.

Triumphal Monuments

The two scenes inside the Arch of Titus show the triumphal procession after the capture of Jerusalem in AD 70, the soldiers with the temple treasures and Titus in his chariot. The use of relief is very sophisticated: by contrasting the angle of Titus and his attendants, the horses and the figure at their heads and of the soldiers in front of them, the sculptor has made the procession seem to come towards us from the right before moving away from us to the left. The procession is given bulk by the use of low relief for the heads and legs of the barely visible escorts behind the horses (Fig. 2.5). The same technique of figures turned towards us and then moving on is also used in the carving opposite, the procession with the Menorah, the seven-branched candelabrum from Jerusalem,

enhanced by a low relief arch towards which the soldiers appear to be moving. Other triumphal arches tend to be more elaborate with sculptured figures, panels and friezes on both faces and on the attic (the top level) as well as in the passageway. Arches throughout the empire whether in Europe at Orange and Carpentras, North Africa, Asia Minor, or Rome and Italy share much the same features. The emperor was shown larger than other figures and in one or more of a series of image-enhancing set scenes. These include the *adventus* or arrival of the victorious emperor,

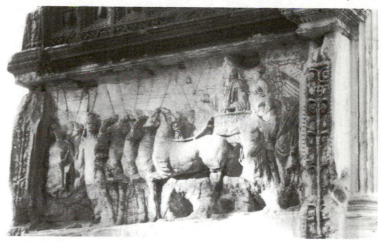

Fig 2.5 Relief from Arch of Titus on the Via Sacra, Rome. The procession appears to be coming forward from the right and moving away to the left.

the *adlocutio*, where he addresses his troops, the submission of the enemy king or the performance of a sacrifice. On the Arch of Trajan at Beneventum the emperor is shown dispensing largesse to impoverished children and receiving deputations. In these scenes the figures dominate and there is less interest in showing the background setting, but there are still realistic touches, the children riding piggy-back and a wriggling babe in arms. The use of divine and symbolic figures continued, but whereas Tellus on the Ara Pacis occupied a separate panel, in later imperial reliefs such personifications often appear as characters alongside the emperor. At Beneventum Trajan is shown with Mesopotamia kneeling before him in the form of a young woman, personification providing useful imagery for the conquered land, just as the figure of Britannia does on the coins of Hadrian. Imagery was often combined with realism: in the great Trajanic frieze of c. AD 117 – which was re-used on the Arch of Constantine – Trajan is shown being crowned by Victory in an otherwise realistic

adventus scene. Victories, winged and semi-nude, are regular features of triumphal arches; their flying figures, bearing torches or trophies of arms were admirably suited to fill the spandrels and also served to point the viewer's gaze upward to the attic storey where there would be further reliefs of imperial propaganda.

The *tondi* (circular panels) of Hadrian's Arch, which were also re-used by Constantine, show him in different pursuits – boar-hunting or sacrificing to Apollo – not so much to record actual events as to suggest his manly, god-fearing character. The reliefs are deeply cut and make good use of the shape in the composition of the scene. There are fewer figures and the setting is suggested rather than detailed. A tree that follows the line of the circular frame sets the scene for the hunt; the subjects, though formalised set pieces, are drawn from real life. A large panel from this now demolished *Arco di Porto Gallo* has a large symbolic panel showing the apotheosis of Hadrian's empress Sabina, where a seated Hadrian watches as Sabina is borne aloft on the back of a figure of victory, such as would appear also on the spandrels of the arch. The siting of the pyre is indicated by the personification of the Campus Martius at its foot. Following Hadrian's taste the figures are carved in noble classical style and it would be interesting to know how easily the Roman viewer read the symbolism.

Panels from a lost Arch of Marcus Aurelius show him in all the con-ventional scenes and have carving so deeply undercut that nearer figures are almost in the round, a technique also seen on his column. Of the arches commemorating Septimius Severus, two in particular illustrate new approaches to relief carving: the triple archway in the Forum Romanum and a tetrapylon, or fourway arch, at the intersection of two main streets at Leptis Magna, his birthplace. At Rome the panels above the side arches show the exploits of the emperor and are crowded with shorter stockier figures; more distant features of the scene are dealt with by providing small shelf-like strips of ground for them to stand on (Fig. 2.6). This technique had been used before to show a *decursio* – a parade of horsemen and legionaries for a state funeral – on the base of a column to Antoninus Pius. Here each prancing horse has its back legs on a little strip, exactly like the bases of toy soldiers, as they circle round the legionaries who stand in the centre on their own 'shelf'. At Leptis Magna the outer faces of the arch are decorated with elaborately carved inhabited scrolls and sensuous figures of Victory, and the relief scenes are restricted to attic and passageway. The attic friezes were to be viewed in strong North African sunlight and so the toga-clad figures were carved with deep-cut definite lines to produce well-defined shadows. The work of craftsmen from Asia

Minor, possibly employed through the influence of Julia Domna, the Syrian wife of Septimius Severus, is evident in the frontal pose of the imperial group. In a scene of triumph they stand facing front in a chariot with horses moving left to right. This frontality and deeply-cut, but less subtle, carving was a growing trend by the third century. Reliefs feature lines of dumpy figures with the imperial family noticeably taller

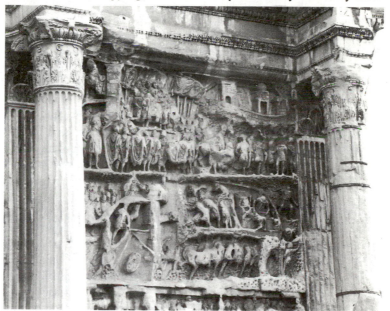

Fig 2.6 Arch of Septimius Severus, Forum, Rome. The lower register shows the siege of Ctesiphon. In the upper Septimius addresses his troops before the captured city. To convey perspective each group stands on its own shelf-like strip of ground.

and facing forward. Because it was important to record who was there, features are carefully delineated but the poses make them appear totally uninterested in what is going on.

Temples and porticoes could also be triumphal monuments. At Aphrodisias in Turkey the Sebasteion, dedicated to the patron goddess and the Julio-Claudian emperors by two local families, consists of a temple and approach road flanked with three-storied porticoes with both Hellenistic and Roman features. The relief panels that decorate them show not only scenes from mythology and *ethne* (personifications of peoples conquered by Augustus) but the emperors in heroic guise. One panel, for example, has Augustus, clad only in helmet and cloak like an

Homeric hero, bestriding land and sea. Is this art as official image-making, or as an expression not only of the donors' reverence for the emperor but of their identification with Rome's achievements?

Columns

Perhaps the ultimate propaganda statements are those made by the columns of Trajan and Marcus Aurelius in Rome, both designed like a huge *volumen* or roll book of illustrations. 128 Roman feet (38m.) high and once topped with a statue of the emperor, Trajan's column shows his campaigns against the Dacians from the first crossing of the Danube to the death of the enemy hero, Decebalus. The scenes which were originally brightly painted merge to form a continuous narrative and the higher stages could be studied from the two libraries between which it stood. The carving in a low relief of about 5cm. runs across the drums in a spiral band 91cm. wide at the base of the column, increasing to a compensatory 102cm. at the top. The detail is extremely accurate, down to the varying kit of the different units. The story begins with the soldiers, their cooking pots strung on poles, crossing a pontoon bridge; standard-bearers lead the way. In contrast with this realism the huge figure of the river god emerges from the Danube to watch them. The expected set pieces, the *adlocutio* (exhortation) the sacrifice, the submission, with the emperor always taller and easily identified, are combined with the building of camps, battles and ferrying horses across the river. The nearer figures in the scenes are shown at the bottom edge of the band standing on the rope-like separating ridge, and depth is achieved by placing those further off higher, as if we were looking uphill, and also by carving them less deeply but with an incised outline to give a defining shadow. Setting aside the propaganda value of the column which also served as a tomb for Trajan's ashes, it is an outstanding artistic achievement. Real characterisation is shown in the faces of the soldiers and the interplay between them in the scenes of building and battle. Much of the detail must have come from personal observation, and one can imagine a war artist with a sketch book accompanying the campaigns and noticing a soldier wading across the river with his kit piled on his shield. In another part a mule with ears laid back has scented the blood of the sacrifice before it and dug its heels in, unseating its rider. This much is observation; the falling rider's arm and leg point up to Trajan on a rostrum – that is design (Fig. 2.7). There is a theory that it was a plain column which was erected between the libraries in Trajan's forum, expressing power by its size alone, and that it was Hadrian who had the carvings added when he

succeeded Trajan. The standard of carving throughout is very high, although many sculptors must have been at work, and the scenes flow into one another with great skill so that its composition has been compared to an epic poem.

On the column of Marcus Aurelius the campaigns of the German and Sarmatian wars are treated as a series of scenes, separated by a decorative

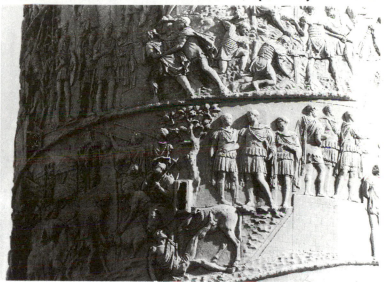

Fig 2.7 Scene from Trajan's column, Rome. The mule has smelt the blood of the sacrifice to the left and with laid-back ears unseated his rider, whose arm and leg point the viewer's gaze up to Trajan, shown taller than his companions.

bar. The deeper cutting and higher relief with the resultant shadows make the figures easier to see. Following the Eastern tradition the emperor is shown frontally and the sense of distance between nearer and further figures is not so well conveyed. In some scenes the further figures stand on their own strip of ground, as we have seen before. Personification again plays a part. Once torrential rain flooded the river and drowned the enemy troops and horses when the Romans were outnumbered. This is conveyed by the great figure of a rain god, hair and beard mingling with the streaming curtains of rain that descend from his arms. There is less detail of the background but more interest in the expressions of soldiers and natives alike. Scenes that show Roman soldiers beheading baggy-trousered natives with bound hands, or roughly rounding-up women and children, emphasise the pity and horror of war – a feeling shared by Marcus Aurelius himself.

Sarcophagus Reliefs

In the early first century AD wealthier Romans began to bury rather than cremate their dead. Perhaps this was because philosophy, mystery religions and Christianity had raised ideas of the immortality of the soul and resurrection. Instead of a roadside stele with simple relief portraits or scenes from daily life, the trend was for a large chest tomb, frequently of marble, and some of the finest relief carving is found on these sarcophagi. Thousands survive and can be seen in most Roman collections and even used as planters in the gardens of stately homes.

There were noble families who had used sarcophagi in the Republic and early empire, sometimes topped with reclining figures in the Etruscan manner. By the middle of the first century AD the use of carved sarcophagi became more widespread, perhaps due to the strength of Greek influence over Roman tastes so berated in Juvenal's *Satires*. Soon the practice spread throughout the empire. Many of these sarcophagi were exported from the marble quarries of Greece and Asia Minor, though the lids were usually carved to order locally, as we can tell from the use of different marble. Greek and Asian sculptors also moved to Italy and on his own tomb one of them, Eutropus, showed himself working at a lion's head on a strigil sarcophagus. Strigil sarcophagi carved with narrow S-shaped fluting, reminiscent of the shape of a bather's scraper, and decorated with lion's heads or blank medallions for portraits were one of the forms that could be mass-produced for export and finished in Rome to suit the patron. Elaborate decorations became the vogue: *bucrania* (bull skulls) and garlands with perhaps masks or figures at the front corners. Scenes from mythology or the life of the departed became more and more crowded with figures. Workshops in Greece, Asia Minor and Italy produced work with distinguishable styles, though there was naturally cross-fertilisation of designs and technique. In general the so-called Attic and Italian sarcophagi were carved on three sides only as they would be stood against a wall or in an alcove in a family tomb, while the Asiatic sarcophagi were carved on all four sides. They also tended to be larger with more deeply drilled carving and statuesque figures; often there is an architectural setting for the figures, which are sometimes so deeply carved that limbs stand clear of the background. The locally carved lids might also have a frieze which could be personalised to meet the patron's wishes.

The subjects chosen for carving on sarcophagi are not a reliable guide to deciding where a sarcophagus was made, as these were virtually mass-produced and not always influenced by the demands of customers.

The simpler form of sarcophagus (Fig. 2.8a) developed into deeply carved reliefs with numerous figures, of which there were a number of popular types. Daily life might be shown, particularly scenes from childhood or the *conclamatio*, with mourners lamenting round the funeral couch. Hunting and battle scenes of great complexity, recalling the reliefs of the imperial columns, were a tribute to the courage of the departed.

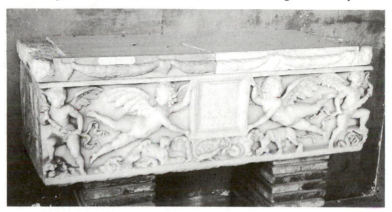

Fig 2.8 a) Marble sarcophagus of F. Valerius Theopompus Romanus, 2nd century AD. Beneath the Cupids the mongoose struggling against the snake symbolises virtue struggling with brute force.

Amid a tangle of battling figures and horses covering every inch of the surface the character commemorated is usually easily identifiable. Scenes from the more dramatic moments of Greek tragedies were popular too and were invested with allegorical meanings. The triumph of Dionysus and similar Bacchic themes might represent the triumph of virtue, and these subjects were sometimes associated with a bath-tub shaped sarcophagus or *lenos*, which imitated the shape of a wine vat. Other subjects were more thematic, Apollo with the Muses or a series of poets, or Dionysus and the seasons (Fig. 2.8b). The spaces between the major figures, even where these stand in elaborately patterned niches and archways, are packed with smaller carvings of Cupids, animals and foliage.

The second century sarcophagus (Fig. 2.8a) represents a common type and shows the merging of Greek and Roman elements. The lid is decorated with masks, a Greek theme, and the bull skulls with garlands associated with the Augustan religious revival, as are the griffins, guardians of the dead, on either end. Cupids appear in all manner of decorative situations, their use in Rome having originated to associate Augustus and the Julian gens with divine descent from Venus. Here two Cupids are corner figures

stamping on rocks and emerging snakes, while two larger Cupids support the inscription panel. Their pose is derived from the Victories of triumphal arches but with one leg uplifted to fill the space occupied by a Victory's larger wing. Beneath this a mongoose is attacking a snake, *virtus* overcoming evil, while on either side are two lionesses with cubs, a Roman use of animals to illustrate human qualities such as devotion.

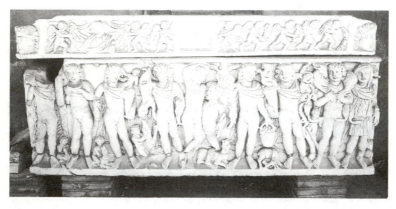

Fig 2.8 b) Marble sarcophagus of c. AD 320 of a style showing Dionysus and the Seasons.

The plump figures are deeply undercut and the Cupids have lively expressions and curly hair. The design follows a type – similar designs occur in Apamea, Syria, with local variations – but the actual carving is of very high quality.

About a century later the sarcophagus (Fig. 2.8b) uses Dionysus and the Seasons to represent the passing of life. The four seasons are shown on either side of a youthful Dionysus supported by a satyr. Looking from left to right, Spring is damaged, then comes Winter who tastes a cup of new wine, and Summer carries a basket of produce. At his feet a Cupid tries to restrain the hound which is leaping for the hare that Autumn holds. On the other side of the satyr Summer holds a branch of flowers and a basket of fruit and has a goat suckling a kid beside him. Autumn is surrounded by Cupids, one on his basket and two climbing in the tendrils of his vine branch. Spring has a sheep on his shoulders and two ducks hang head down from the warm clothes that Winter wears. Notice how the Cupids (one is missing, top left) and animals fill all the spaces, yet a pleasing rhythm is given to the composition as a whole by the line of torsos all slightly different in pose. By contrast the lid appears rather amateurish: puny Cupids hold a curtain with crudely drilled folds behind

a bust of the departed. Others support the memorial tablet or carry sheaves representing the final harvest. Theatre masks, as so often, provide *acroteria*, the flanking corner decorations. A most beautiful version of this theme, the so-called Badminton Sarcophagus, now in New York, is one of the masterpieces of this form of relief. The four seasons with satyrs, Cupids and personifications frame Dionysus on a panther, all in very high relief.

Decorative Relief

We see the same delight in carved decoration in the architectural use of relief. The Corinthian capital becomes ever more extravagant; a horse appears about to leap out of a capital from Trajan's forum and in the baths of Caracalla Hercules lurks among the acanthus leaves of another. In Leptis Magna he performs all his labours in the arabesques of the carved pilasters at one end of the Severan basilica while Dionysus and the grape harvest is celebrated at the other (Fig. 2.9). This is in the tradition of earlier work at Pompeii where an inhabited scroll, a sinuous foliage pattern (*rinceau*) with birds and insects among the leaves, decorates the doorway of Eumachia's building in the forum. These widespread motifs are in the tradition of the leafy scrolls of the Ara Pacis. Stucco decorations of moulded plaster, used for ceilings or enhancing wall paintings, also borrowed these wreathes and garlands. They appear in painting too; at Oplontis the white wall of the garden portico is painted with scrolls of flowers and foliage inhabited by tiny mice, grasshoppers and lizards, all carefully observed and enjoyed. This style of decoration for the pure pleasure of it passed into European artistic language and emerges in many forms from embroidery to illuminated manuscripts.

Fig 2.9 Relief from the basilica of Severus at Leptis Magna, Libya. The inhabited scroll has Cupids harvesting and a bird pecking grapes.

Chapter 3
Painting

Beginnings

In 214 BC after the Romans defeated the Carthaginian general, Hanno, the townsfolk of Beneventum laid on such a party for them that Gracchus had the scene painted and hung in the temple of Liberty (LIVY, XXIV 16). When Rome was still fighting to establish its power, the desire to record was so great that even then war artists were on hand to paint narrative scenes of victory to be carried in the triumphal processions of successful generals. Etruscans to the North and Lucanians to the South had traditionally painted the interior of their tombs, and so presumably of their houses, and Pliny in *Natural Histories* XXXV cites examples of paintings in public places in the second century BC. We can therefore claim that native painting existed. However, just as in the case of sculpture, it was when Greek paintings began to arrive in Rome and were put on display in temples and basilicas that they became objects of desire to wealthy Romans. According to Pliny, works by all the big names of Greek painting, Zeuxis, Apelles, Timanthes, were on show in Rome and contemporary artists had sufficient examples of their works to produce versions to suit their clients. We cannot tell how many copies were made on wooden panels which have not survived, but we can imagine what Roman taste must have been from the subjects chosen for the pictures they incorporated in the decorative schemes adopted for their houses. By the early empire it seems that the interiors of most buildings were painted from temples down to bars and the technique was fresco, where the paint is applied to damp plaster.

It is interesting to speculate what scholars would make of present-day appreciation of painting if they had to draw their evidence chiefly from a minor commercial town with a small port, its more residential neighbour and three or four nearby country-houses. Wall-paintings have survived in Rome and various other places and periods but, by the accident of their preservation, the buildings overwhelmed by the AD 79 eruption of Vesuvius have supplied the majority of examples of Roman painting. These date from the very time when Roman interest in art had been awakened by Greek works, and cover a period when different

manners of painting walls were being explored. In 1882 the scholar August Mau classified them as being in four successive styles. His system gives a good idea of how painting developed but there is some evidence from other areas that the different styles of painting were being used simultaneously. Useful as it may be to know these styles, there is more to Roman art appreciation than correctly identifying the style of a particular painting.

First and Second Style

In the First or Masonry Style stucco was used to divide the wall into regular areas and then painted bright colours as well as colours that imitated different stone and marbles. Such schemes were in use at Pella and other centres of the Hellenistic world. The divisions began with a dado at the base with a string course to divide it from the *orthostates* (large panels imitating stone slabs). Then came a frieze which was more or less at eye level and so carried the most decoration. Above this were painted two or three courses of large 'stone' blocks over which there would be a frieze and cornice. Variations of this were possible with friezes and cornices added or patterned in stucco, like the egg and dart pattern in the Samnite House at Herculaneum. This house has an open gallery on one side of the atrium and on the other three walls this is imitated by stucco columns and balustrade. In the first century BC it was realised that this deceiving of the eye (*trompe l'oeil*) could be much more easily achieved in paint.

The wall continued to be divided into three zones and in the Second Style over these were painted details such as a balustrade or podium from which painted columns rose to support a cornice or entablature. This had the effect of pushing the walls back by showing a wall surface apparently lying further behind. By setting such painted columns on individual bases that seemed to be projecting forward, an illusion of floor space at the base of the wall was added, as in the Villa of Oplontis (Fig. 3.1). The perspective was dealt with from a central viewpoint and the light to give the enhancing shadows on which *trompe l'oeil* often depends was assumed to come from the doorway. A further development was to paint the top third of the wall as though one could see outside to a further space with a receding colonnade. Doors or gates were painted in the centre of a wall framed in elaborate doorways beyond which a colonnade or a shrine might be glimpsed. Once the painting of illusory space began artists became more and more inventive. In the House of the Labyrinth in Pompeii there are fluted columns superimposed on the *orthostates*,

then curtains are painted stretched across the lower part of the upper zone, as though they hung behind the suggested inner wall, and above them the painter has added the columns and architrave of a portico as a further plane of illusory space. For good measure two birds are painted perched on top of the curtain. As well as birds, theatre masks are constantly added either resting on an imaginary shelf or suspended above an 'open' view. They are so pervasive at all periods that they must have signalled some desirable social attainment such as a knowledge of Greek literature.

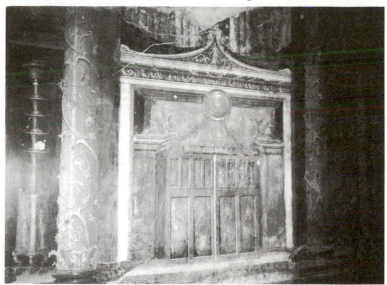

Fig 3.1 Second Style painting from the Villa of Oplontis. The encrusted columns appear to stand before the gate with griffins on the gateposts. A colonnade is seen in the further distance.

By the use of shadowed and highlighted detail painters also suggested that, while there was a further 'space' beyond the emphatically coloured *orthostates*, the cornice above them projected to form a nearer plane. The illusion of the shelf was created by painting a partial view of the underside with small brackets, each with its shadow. Thus far the painter at Oplontis must have been working from below; then mounting a ladder he added on the shelf a glass bowl of plums and pomegranates, some seen through the glass, some mounded above it. Alas, he has set the bowl on a small base of which he has painted the upper surface, correct from his higher vantage point, but a nonsense viewed from below. This anomaly of eye levels occurs again when the schemes become even more ambitious and whole sections of wall are 'opened', as at Boscoreale, to offer a vista

of lofty buildings. The lack of a rational eye-level makes these inconsistent and uneasy on the eye. Other more successful sections of the wall in this bedroom show a garden with an arbour and birds visiting a trough of water. In effect the walls have become 'windows' on an imaginary world. In a house lit via the *compluvium* (the opening in the atrium roof) rather than by windows and where the rooms were not large, a scheme that pushed the walls further back and pretended to give a view of the outside world must have been very attractive. The younger Pliny in describing his country villas lays great stress on the views they enjoy and how the buildings have been planned to take advantage of them. The patrons who had their walls painted in this style could have views wherever their house was situated.

Later stages of the Second Style concentrated more on architecturally based designs, made to seem 3-D, but with less emphasis on a view through the wall. An architectural framework converted the whole wall to a niched edifice reminiscent of the *skene* wall of a Roman theatre or, in larger rooms, a pilastered wall with central feature such as a delicate version of a triumphal arch with tall slender columns. The figure-paintings appeared in these niches and recesses or along the frieze. Details at the end of this period have changed too; in place of *trompe l'oeil* baskets of figs or jugs, there are masks framed by daisy chains or flamboyant griffins (Fig. 3.1). It is in the imperial houses on the Palatine that the innovations – which Vitruvius, the Roman writer on architecture, condemns – first appear: columns that seem to have grown out of flower bulbs, grotesques, part beast, part volute, and figures that rise out of candelabra. 'No such things exist, they never have and never can'. (VITRUVIUS VII 5.3.) He declared that painting should imitate reality, yet this realistic treatment of architectural features with glimpses of views beyond was in fact creating an illusion. Artists however, presumably encouraged by their clients, continued to enjoy adding birds perched on cornices, columns encrusted with flowers or Silenus with volutes for legs in defiance of reality.

Third Style

Mau gave the name of Third Style to those schemes which made no attempt to convey that the wall was anything but a flat surface for decoration. Architectural shapes remained but there is little attempt to make them appear anything except two-dimensional. The attenuated columns form a framework to be enriched with patterned friezes or to set off paintings. Walls were divided as shown in Fig. 3.2, though the

number of panels might be more on longer walls. The focus of interest was the central section of the main zone which was often painted with the conventions of a doorway with flanking pillars and pediment or overmantel. There the resemblance to a doorway stopped. There was no impression of depth and the spindly pillars and the overmantels decorated with grotesques (motifs combining figures of satyrs or animals with

Fig 3.2 In the Third Style walls were treated as a flat surface and decoration was organised in nine or more panels with the most important painting in the central panel of the main zone.

tendrils) bore no relation to reality. Their purpose was to enhance a painting of a landscape or mythological scene. On either side were panels in a strong colour; red, yellow and black were popular, and these might have a patterned border and a small 'floating' figure or realistic bird painted at eye-level. The dado, no longer a podium to support the pillars, was often painted black and decorated with patterned rectangular or diamond-shaped panels. Friezes painted in bright patterns bordered the top and bottom of the main zone, sometimes replaced by figured panels with scenes from mythology or everyday life. The upper zone tended to retain the outline of a central *aedicula* (small porch-like building), framing a figure or a view of a portico. At either side a small landscape panel might be added. In the *caldarium* (hot room) of the Villa of Oplontis the story of Hercules' quest for the golden apples of the Hesperides is shown against a romantic landscape in arched frames on three walls. The flanking plain red panels have a black frieze and painted cornice, while the upper zone

in deep yellow has a small figure in a swagged *aedicula* with on each side an improbable peacock perched on a small painting that imitates a wooden panel-picture. This design and colour scheme are echoed in the ceiling. Ceilings in stucco were also common, both in decorated geometric patterns and in simple frames with rustic scenes or small figures and motifs.

The possibilities of variation on the basic Third Style scheme were enormous. The dado might be painted with heads poised on volutes or naturalistic plants. In the *triclinium* (dining room) of the House of the Moralist in Pompeii the main zone is divided into alternate red and black panels with a yellow patterned border and alternate garlands and birds at eye-level. The Villa Farnesina in Rome had a black walled *triclinium* with spidery landscapes on all the divisions of the main zone with garlands of ivy slung between pencil-thin pillars. A patterned frieze above and below enlivens this main zone with bright blue and yellow. Another room features willowy caryatids partway up columns who hold floral garlands between them and, on an entablature, which theoretically is too heavy for them to support, rests a wide frieze of birds and theatre masks. The main zone is left a plain white and the emphasis is on the remarkable beauty of the faces of the caryatids and the expressions of the masks. More and more elaborations were devised: pillars ending in medallions, the main zone divided not by pillars but by ornate candelabra, canopies on the thinnest of columns and hung with garlands occupying the upper zone and framed small paintings inserted at every level. It is the Third Style that was copied in the eighteenth century in the Pompeian rooms of stately homes like Ickworth in Suffolk.

Fourth Style and Beyond

If Vitruvius disliked the Third Style, he would have disapproved of the Fourth still more. The elaborations continued, borrowing ideas from the previous fashions and using them in what often seem contradictory combinations. The idea of the open wall returned and architectural perspectives with spindly yellow columns are seen through narrow 'openings' and are often combined with figures who stand in doorways or in the upper zone pavilions. These vistas generally had a white background and were used in combination with yellow, red or white panels containing smaller and less dominant paintings than in the previous style. These panels often have a patterned border and in several houses one or more of them is shown with a curved dip at the top as though curtains were stretched between the uprights (Fig. 3.3). This device and the style of the borders suggest that the designs may have been borrowed from embroidery.

Insubstantial canopies, porticoes and balustrades begin to dominate the upper zone and are painted on a white ground. Though this does not push the wall back as realistically as in the Second Style and the structures often make no architectural sense, the white ground lightens the impression of the wall, giving the feel that there is space beyond. Further ornamentation follows: delicate garlands are hung between

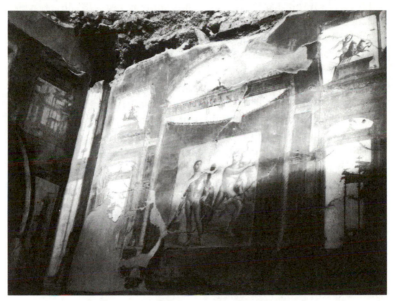

Fig 3.3 Fourth Style painting from the College of the Augustales, Herculaneum. The main painting appears to be hung on a curtain and the spindly pavilion to the lower right is unrelated to the heavy base above bearing Victory in her chariot.

candelabra and held by grotesques, and animals or birds balance on parapets. In contrast the dado receives the least attention, either painted to look like marble or patterned with threadlike yellow garlands.

Nero's Golden House in Rome was decorated at this period in the first century AD and the slender architectural framework with narrow receding vistas of a two-tiered portico is used to decorate corridors. The ground is white and figures are painted in some of the openings. The whole effect is rather that of looking into uncurtained lighted windows. The yellow room in the House of the Vettii at Pompeii illustrates a different way this window impression was used. The wall is divided as in the Third Style and the dado is painted red with yellow decorations. Important square mythological paintings occupy the centre of the three yellow central sections of the walls and these are flanked by large architectural compositions against

a white ground which occupy the upper two-thirds with small panel-paintings below. The effect is of a yellow room with windows and the paintings of Pentheus, Dirce and the infant Hercules appear to be thrust forward. Another feature of this richly decorated house is the *triclinium* where the red walls are divided horizontally by black bands with candelabra, open twisted columns, foliage and little panels of Psyches picking flowers below. Similar horizontal bands contain the well-known scenes of Cupids busy at a variety of trades.

Mau also assigned the large all-over scenes, where one subject covers a whole wall, to the Fourth Style. Among examples at Pompeii are the wild beasts in the House of the Ceii, or in the house of Orpheus, the delightful scene of the minstrel charming the wild beasts with his lyre, with a companionable lion beside him. These large schemes are more akin to what would now be called murals and do not seem to fit as comfortably into their settings as the framed mythological paintings and landscapes.

The white-ground schemes persisted after the airy-fairy architectural fantasies of the upper zone became less popular. The frameworks defining the subdivisions of the wall became even more attenuated. Fine garlands or lines of pattern divided surfaces of both walls and ceilings into frames for motifs of baskets, masks, cupids, rosettes and birds. By the third century much of the evidence comes from catacombs and these subdivisions had lost any kind of relation to architecture.

The Pictures

Thus far we have considered the overall scheme of wall-paintings, but the pictures from small 'floating' studies of Cupids, lovers or birds (Fig. 3.4) to wall-wide scenes are worth closer study. As we saw with reliefs Romans liked art that told stories and the first figure-paintings were introduced in narrative friezes. Like a strip cartoon without boxes, a story would be told against the same mythic landscapes of trees, rocks and palaces. In the Odysseus frieze, now in the Vatican Museum, following the Roman convention of continuous narrative, the same characters appear more than once in the same scene. Almost dwarfed before her palace, Circe both welcomes Odysseus at the door and a little to the right kneels before him as he draws his sword. In a large frieze-style painting on three walls of a room in the Villa of the Mysteries a Dionysiac ritual is taking place against red *orthostates*. The nearly life-size figures with expressive faces seem to interact with those on the other walls and there is a rhythm in the groupings of mythological beings and humans at each

stage of the ritual. The masterly painting is at its best in the arrested movement of the initiate in the cloak with her expression of fascinated awe. The Roman satirical writer Petronius describes a frieze where Trimalchio has vaingloriously had his own adventures painted with the same mix of divine and human figures (*Satyricon* XV 29). The well-known painting of a cithara-player with a nervous girl behind her chair comes from another large scale frieze from Boscoreale.

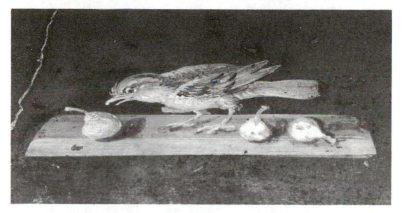

Fig 3.4 One of a series of bird studies 'floating' on dark red panels at the Villa of Oplontis.

In the Third Style the emphasis was on panel-paintings. Small panels placed on the cornice, sometime imitating Greek originals to the point of being painted as though they had wooden shutters, had been introduced in the Second Style. They continued to be used in various parts of a scheme, e.g. attached to a candelabra. The subjects included neatly painted facades of gleaming villas, Dionysiac revels, impressionistic landscapes and, occasionally, Egyptian gods. The main focus, however, was in the centre of the main zone – a painting of a mythological scene in a landscape visible, as it were, through a window. The reality of the landscape was reduced by the Roman tradition of painting several episodes in one. Such landscapes are often inconsistent in scale and in geography. Such a painting contains Andromeda chained to a rock, her grieving mother, Perseus flying to the rescue, and his subsequent meeting with Cepheus. As the Third Style gave way to the Fourth these central pictures were less elongated and the figures became more important and occupied more of the space. Only the identifying moment of the story is shown; in a later painting of the same subject Perseus assists Andromeda

down from the rock with only Medusa's head slung on his sword to convey the rest of the story (Fig. 3.5).

Other pictures are set against architectural backgrounds with spectators grouped at different levels to give depth and focus attention on the

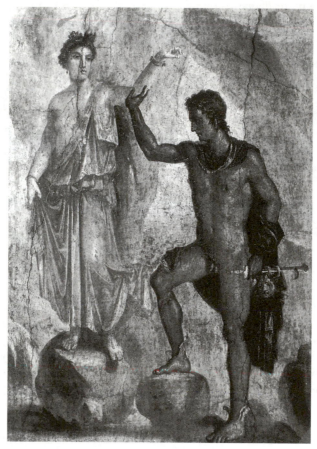

Fig 3.5 Perseus and Andromeda; only the head of Medusa on his sword belt hints at the rest of the story.

main characters. In the painting of Daedalus in the House of the Vettii he stands at ground level, presenting the wooden cow to Pasiphae whose chair is on a dais, and behind her are spectators at a further, higher level. The three heads of the man, woman and cow, form a unifying triangle. Figures in these Fourth Style pictures are boldly painted, the moulding shown by convincing highlights and shadow; the direction of a look could be shown by a highlight in the eye. In Hercules discovering

Telephus from Herculaneum (Fig. 3.6) the rounded figures of Hercules, the infant Telephus and Pan contrast with the statuesque personification of Arcadia. The arms and gaze of Hercules and the winged figure make a strong diagonal down to Telephus suckling from the sympathetically modelled hind who licks his leg. The contrasting line takes us from Hercules' leg through the diagonal pose of Arcadia to the mischievous face of the young Pan.

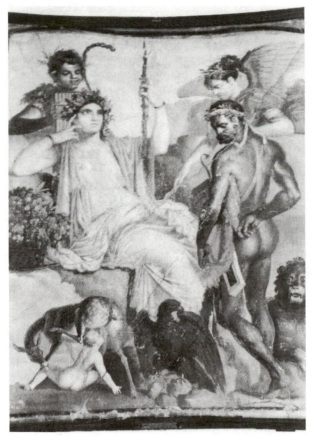

Fig 3.6 Hercules discovering his son Telephus, from the basilica, Herculaneum.

We know from Pliny the Elder that many of these mythological paintings were derived from Greek masterpieces. What we do not know is how much depended on copybooks, the skill of the artist or the demands of the patron. There are several versions of the most popular subjects, e.g. Theseus after slaying the Minotaur and Achilles on Scyros

which seem to come from the same original. The Perseus and Andromeda (Fig. 3.5) appears to reproduce the painting by Nikias, but in another version Andromeda has become somewhat willowy and a watching nymph has been added. Pliny describes the subjects of numerous Greek masterpieces but even paintings like the Infant Hercules strangling Serpents in the House of the Vettii, which seems to fit his description of a work by Zeuxis (*Nat. Hist.* XXXV 64), may not be an exact copy. Pliny's descriptions mainly suggest that Roman patrons chose mythological subjects made famous by Greek painters, particularly those that implied a knowledge of Greek and Latin literature. Stories from Homer and Greek tragedy or made famous later by Ovid appear in rooms used for entertaining. Perhaps the owner wanted to show his cultured tastes, as though he had a gallery of Greek originals like the nobility.

The sacro-idyllic landscape, so called because it features small shrines in pastoral scenes that recall Theocritus and Virgil, is the other subject which occurs frequently. Pliny attributes the introduction of this genre to a Campanian painter named Studius, in the time of Augustus, who

> first introduced the most attractive fashion of painting walls with villas and colonnades and gardens, groves, woods, fish-pools, rivers, coasts, or whatever anyone could wish, along with sketches of people strolling or sailing or going to country-houses by donkey or coach, as well as people fishing, hunting and picking grapes...giving a most delightful effect at no great expense. (PLINY, *Nat.Hist.* XXXV 116)

These idealised landscapes appear in friezes and small panels as vignettes 'floating' on a pale ground and as the subject of the central section of the main zone. Typically, these are on a white ground and have a shrine or group of buildings as a focal point, with impressionistically painted trees, rocks and pastures and Lowry-like figures in the foreground (Fig. 3.7). Villas, seashores and harbours are painted in the same way with daring splashes of white to indicate the play of light and the distance shown in hazy atmospheric perspective. The handling of light and confident brushstrokes are in the manner of Turner. A herdsman brings a shaggy ram to a country shrine at the foot of a rocky cliff, the light bouncing off his back, the pillars of the shrine and the rocks above, while the distant scene is conveyed in blurry blues and greens.

Much bolder nature-paintings occur in the garden scenes that cover the walls of enclosed *peristylia* 'garden courtyards', and summer dining rooms. Painted with free brushstrokes but close observation, they show

laurels, oleanders, viburnum, rose bushes and fruit trees, often behind a fence, interspersed with recognisable flowers and ornamental fountains, (see Fig. 6.6, p. 85). These served as windows onto an enchanted landscape thronged with thrushes, wood pigeons, ibises, herons and peacocks, and pushed back the walls of tiny *viridaria* (gardens). Pliny the Younger boasts that he has a green and shady room in his villa decorated with

Fig 3.7 A sacro-idyllic country scene with a port and a fountain statue of Poseidon from Villa Farnesina.

marble and 'a fresco, no less attractive, of birds perching in the branches of trees' (PLINY, *Epistles* V.6). The garden room in Livia's house at Prima Porta had a painted orchard on all four walls. Behind a lattice fence and a low stone wall are fruit-laden trees, shrubs, flowers and birds that flourish together regardless of season and provide an illusion of a garden retreat to be enjoyed whatever the weather. In one painted garden a little white dog called Sincletus has been added, showing that the poet Martial's friend Publius was not the only Roman to have his pet painted so well that you could not tell which was the dog and which the picture (*Epigrams* VIII 71).

The illusion of greater space and light in rooms that were often dark and restricted was clearly one of the first demands made by patrons. They wanted to show their prosperity by use of expensive colours and, incidentally, by still-life studies of their silverware, glassware or of *xenia*, the fruit and game they were to offer to guests. Mythological subjects proved they were cultured; country scenes perhaps look back to the yeoman farmer traditions represented in Virgil's *Georgics*. In addition it is hard not to

feel that both painters and patrons enjoyed cleverness for cleverness' sake – the skill of representing a tray of cakes covered with a gauze cloth (Fig. 3.8). In the same way they enjoyed *trompe l'oeil* and Pliny's stories of birds that tried to eat painted grapes or were silenced by a painted snake (*Nat.Hist.* XXXV 65 & 121). Painting should imitate reality, according to Vitruvius, and this was generally accepted and supported by the later writers on art, e.g. Philostratos the Elder (Eikones 1 *Proem*). Yet artists and their patrons could not resist *jeux d'esprit* – a besom leaning against 'steps' or peacocks perched on entirely two- dimensional cornices with the shadow of their necks thrown against their own tails. But what impresses most is the number of competent, and not a few really talented, painters there must have been available to decorate Roman houses.

Fig 3.8 A tray of cakes covered with a gauze cloth in a Second Style painting at the Villa of Oplontis. The wickerwork table appears to stand on the plinth from which the column at right rises.

Chapter 4
Mosaics

Mosaics are popularly considered a thoroughly Roman achievement but this is a mistaken belief. The use of mosaics could have come to Rome from the Hellenistic world in several ways – Roman merchants trading and building in Delos, contact with the Greek communities in the South of Italy and the conquests of generals in Asia Minor. So in the first and second centuries BC in Italy the finest mosaics were Hellenistic work. The famous floor from the Temple of Fortuna at Praeneste, for example, was probably the work of artists from Antioch-on-the-Orontes or Alexandria and, according to Pliny, was laid by order of Sulla (*Nat.Hist.* XXXVI 189). The course of the Nile with vignettes of wild animals, fishermen, a picnic or a temple festival is shown in vivid detail. It is one of the earliest of the mosaics in Italy but it is not an early mosaic.

Pebble mosaics were being laid in Pella in the fourth century BC and all the common design motifs of meanders, waves, scales and interlaced circles are found. As well as geometric designs paintings were copied in pebbles, with lines of darker colour to show moulding or shadows. By the second century BC the Hellenistic mosaic schools of Asia Minor and Alexandria were flourishing. They used not only *tesserae*, square cut pieces of coloured stone or tile, but smaller pieces cut to shape for details, as well as *smalti*, vitreous pieces custom-made for colours that stone could not give. Works like the Battle of Issus between Alexander and Darius, now in Naples Museum, copied the techniques of painting with highlights, shadows, foreshortening, atmospheric perspective and finely graded shading. In Antioch-on-the-Orontes mosaics derived from paintings continued into the third and fourth century AD and remarkable examples such as the drinking contest between Dionysus and Heracles, now in Princeton, USA, imitate paintings of the Second Style and show scenes with three-dimensional effects. The use of shadow and perspective gives the same illusion of space as do the paintings they copy, but these mosaics cannot have worked as well on the floor as they do now on museum walls. Roman taste admired this cleverness that deceives the eye and had copies made of illusionist mosaics, such as the *asaroton*, or unswept floor, with the debris of a dinner party, crusts, nutshells, even a

mouse, shown with shadows to give an illusion of depth. These and the very fine panel-mosaics were luxury objects for the very wealthy, created by Hellenistic artists. Sometimes their work is signed, as in the case of the panel of street musicians from Pompeii by Dioscurides of Samos.

Much prized and copied were small panels in very small *tesserae* and finely shaded colours, such as the small mosaic of pigeons drinking from

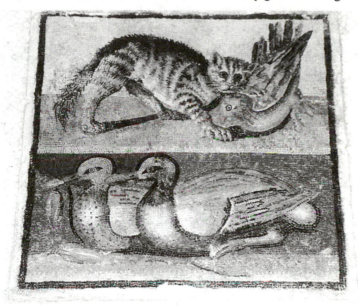

Fig 4.1 There is more than one version of this mosaic panel of a cat and birds in *opus vermiculatum*.

a brass bowl which came from Hadrian's Villa at Tivoli. Still life studies of fruit or game (*xenia*) and small scenes to fit a threshold, form a centre-piece, or occasionally to decorate a wall, were also worked in this *opus vermiculatum*, which was the most expert work, in which the much finer *tesserae* were cut to shape for eyes and details (as in Fig. 4.1). A wider range of colours was used, so finely graduated that they reproduced the shading of paintings. It must have been works of this scale that, according to Suetonius, Julius Caesar took with him on campaign *(Julius Caesar 46)* and fine mosaics were moved and re-used even in antiquity. In Book VII.i, Vitruvius tells us how the *statumen* – the three-layer base of conglomerate, *rudus* (mortar) and fine plaster bed (*nucleus*) – should be laid down and the finished mosaic rubbed smooth. As mosaics were lifted for display in museums it was revealed that often the *emblema* (the detailed

pattern or figure) had been laid in a different colour *nucleus*. It could be made in the workshop either face up on a tray or, by using water-soluble glue, the *tesserae* could be fixed face down onto the design painted on cloth. When it had been placed in position, assistants could complete the border or grid often in larger *tesserae*.

Everyday Roman republican floors were more practical than artistic – herringbone tile, irregular pieces of coloured stone and marble set close, rather like miniature crazy paving, or set in concrete both at random and in simple patterns. They were much like the patterns we associate with vinyl flooring. Judging by the houses in Pompeii, by the end of the republic and in the early empire mosaics were in popular demand even in less wealthy homes. Simple black-and-white geometric borders outlined the room, while the main area was covered with a carpet-like design of black on white or white on black, dotted with small devices. By using less expensive black basalt and white marble or limestone, along with pattern books of geometric designs, mosaicists could supply this increased demand. Patrons could choose more elabo-rate designs for the *fauces* (entrance hall) or an important room, but as wall-paintings increased in richness and colour clearly the need was for a floor that did not compete. Mosaic floors were expensive and time-consuming to lay and very durable, but occasionally another mosaic design might be laid over the top, as fashions changed. Such a two-layer floor with a polychrome mosaic over a black-and-white pattern can be seen in the Roman palace at Fishbourne.

Black-and-white Mosaics

Black-and-white mosaics should not be thought of just as a cheaper alternative to polychrome designs. Imperial palaces or public buildings might have both black-and-white and polychrome mosaics as well as expensive *opus sectile*, floors of bold geometric designs in coloured marbles; the technique was also used to make pictorial panels. Mosaics with black figures on a white ground were chosen to enhance a principal room or decorate a public building. This was already happening in Pompeii and Herculaneum; at Ostia, where the floors mostly date from the first century AD onwards, we can see how the depicting of figures developed. The simple dog on a lead from the *fauces* of a house in Pompeii is shown in profile and what little moulding there is is achieved by the *andamento*, or course of the lines, of black *tesserae* (Fig. 4.2a). At Ostia figures are shown in three-quarter or frontal poses as well and lines of white *tesserae* are used to indicate details of muscles, features or garments,

complemented by the *andamento* (Fig. 4.2b). Large areas of white *tesserae* also posed a challenge. A whole background with straight lines of *tesserae* parallel to the border is unpleasing to the eye. In a well-laid mosaic the *andamento* moves from following the straight border through soft contours until it outlines the figures.

Black-and-white mosaics can be regarded as a specifically Roman genre and the important public buildings in Ostia show how well suited

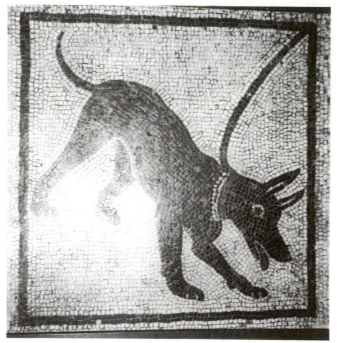

Fig 4.2 a) A *cave canem* panel for a *vestibulum*; moulding is shown only by the *andamento*.

to large vaulted areas these black-and-white mosaics were. Most of the designs were strong and uncluttered, unlike reliefs of the same period which were so often crowded with figures. Background was rarely shown though figures might have a shadow or a small strip to stand on. Sometimes the sea was indicated by short irregular lines to suggest ripples, but a better solution was leave the white ground to speak for itself. In some of the large bath-mosaics the problem of viewpoint is solved by having the sea monsters that surround the central sea god correct for each of the four sides. Black-and-white mosaics lend themselves well to *rinceaux* patterns, such as the decorations in Fig. 4.2b, and to inhabited scrolls; the

Baths of the Seven Sages, in Ostia, provides a particularly good example. They had practical applications too in defining the use of an area, either by an illustration, e.g. the two wrestlers in the 'ring' of the *palaestra* at Ostia, or by wording. In the Square of Corporations each of the seventy-eight offices had a mosaic in the colonnade in front indicating the nature

Fig 4.2 b) The sign from Statio 52, Square of Corporations, Ostia; detail and moulding is shown in white.

of the business – shipping line, date importer or circus animal shipper –
with words and/or illustrations (Fig. 4.2b). Other floors show realistic
farm-carts or scenes of sacrifice. Ostia also has 'carpet' mosaics in black-
and-white, some with sophisticated geometric designs; but more often
geometric mosaics are polychrome, using a range of coloured stone and
marble.

Geometric Mosaics

The angle of view is not a problem for mosaics in an all-over geometric
design and, given a basic design, an infinite variety of effects can be
achieved by use of different colours and methods of subdividing the basic
shapes. A pattern of interlacing circles can be elaborated by changes of
colour, *andamento* and subdivisions to produce hundreds of different
floors. Simple meander-borders, complex three- or four-band frames for
a central *emblema*, and 'flower' patterns were all built up from a geo-
metric basis. They were used to form 'carpets', 'mats', borders, to fill
apses, outline the *impluvium* (the pool in the atrium), or mark out a corridor
and were often preferred in a *triclinium* because the viewpoint was the
same for all the diners. The Roman pleasure in illusion which we saw in
wall-painting also applied to geometric mosaics and we find designs of
receding tricolour cubes and shaded, apparently hollow cuboids, all
achieved by the use of diamonds, squares and triangles and the line of
andamento. Floors that appeared to undulate were created by counter-
changed scale shapes or diminishing triangles; these designs give such a
feeling of movement as to make a sensitive viewer feel quite queasy
(Fig. 4.3).

Bands of *guilloche* (plait pattern) were combined with geometric
shapes to give many forms of grid which provided a variety of frames
for small illustrations. In Roman Britain a central square or circle
surrounded by four lunettes was widely used. At Fishbourne there is a
mosaic with Cupid astride a dolphin in the central circle and sea monsters
in the four lunettes, the intervening spaces filled with urns; similar
schemes can be seen in Colchester and Verulamium museums. These
guilloche and double *guilloche* grids were designed to give squares, circles
or polygonal shapes which could be filled with *emblemata*, sometimes
showing a simple bird or animal, sometimes a more complex figure from
myth or daily life. Themes for such grids were easy to find: the Seasons,
the Months, the Muses, or Dionysus and his followers. Roman subjects
were gradually added to the repertoire of designs. In North Africa there
are frames filled with victorious charioteers from the circus, or famous

horses; these subjects also occur in Britain. Depicting the frontal view of a four-horse chariot created quite a problem and examples bear comparison with representations of triumphal chariots in reliefs. In Roman Germany the grids are so complex and highly patterned that they tend to overshadow the subjects, often Dionysiac, which they frame. One of the most elaborate grids is in a villa at Nennig in Germany, where in a

Fig 4.3 A black-and-white mosaic with coloured *emblemata* and '3-D' border, one of a number of versions of this design.

framework of dizzying complexity gladiators, beastfighters, wild animals and the accompanying musicians bring the Games to life (Fig. 4.4).

Figure Mosaics

Coloured figure mosaics have perhaps the most appeal today. They are also the hardest to look at critically because we become engrossed in the subjects depicted whether in large scenes, set pieces or smaller *emblemata*. We find ourselves seeking for what we can learn from them. What animals are being hunted? What version of a myth is being told? How were the crops harvested? Is that how chariot horses were harnessed? The range of subjects treated in figure mosaics is enormous and varies from area to area.

It may be from the accident of survival but the majority of figure mosaics are found not in Italy but in the provinces. The second century AD was a prosperous time in the Eastern Mediterranean provinces and

this is reflected in the quality of the mosaics which often seem to copy paintings. In a *triclinium* at Antioch-on-the-Orontes there is a scene of Dionysus' drinking-contest with Hercules which, despite being a floor mosaic, is framed in an arched recess in the Second Style of Pompeian wall-painting. In the House of Dionysus at Paphos in Cyprus where splendid mosaics were being laid in the third and fourth centuries too,

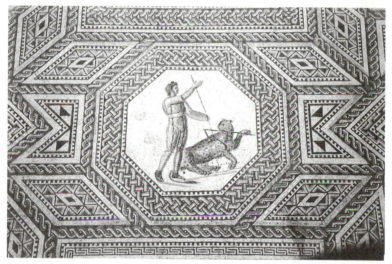

Fig 4.4 A bestiarius; part of the large geometric mosaic with *emblemata* of the Games, Nennig, 3rd century AD.

the story of the god is depicted in panels crowded with figures with expressive faces, each named. The baby Dionysus is shown surrounded by allegorical figures in a composition resembling a Nativity scene. It seems likely that travelling Hellenistic mosaicists left schools in the different areas of the empire where they had worked, offering copies of Hellenistic originals with local variations. So in Roman North Africa Dionysus was also a popular subject: he rides a lion in El Djem and in Sousse a carriage with impressively naturalistic tigers. The inhabited scroll and designs of vine leaves or acanthus, reminiscent of the Ara Pacis, surround the figures with flowers and vegetation. This reflects the prosperity and standing of North Africa that came from its agricultural wealth and its connection with the Emperor Severus. Large scenes show hunts, harvesting, the vintage and fishing. Often these are carried out by Cupids, the children of the Nymphs, who also accompany the main characters in mythological mosaics. It is interesting to compare these winged and naked little boys as they are shown in different areas. In the

Bignor villa in Britain we see podgy two-year-olds playing at gladiators; the fishing Cupids of Piazza Armerina in Sicily are about a year older. In North Africa slimmer five-year-olds accompany Venus or Dionysus while in Antioch-on-the-Orontes we find sturdy lads of six or seven.

Sea gods and attendant creatures, realistic fish and wildly imaginary sea-tigers, sea-horses and sea-deer remained the favourite subject for public baths. Instead of the black-and-white of Ostia, in North Africa Nereus, Triton and their companions are delicately coloured and of enormous size. In Spain, where mosaics seem to have been influenced by North African work, the head of Oceanus at Merida baths fills a whole apse, the pupil of one eye formed of over 300 *tesserae*. In private houses mythological subjects often appeared in square panels within geometric patterned frames or plainer 'carpets' and showed the key moment that identified the story – the eagle carrying Ganymede up to Mt Olympus or Leda with the swan. In Britain, where at least six schools of mosaicists have been identified, the school in the Cirencester area is known for its Orpheus pavements with the musician surrounded by bands of wild animals; this subject occurs again, differently treated, in Sicily. Scenes of hunting show both conventional features, e.g. the sacrifice to Diana, and local variations of costume and quarry: hares and foxes in North Africa or deer in Northern France. These appear on a hunting mosaic in Lillebonne which is signed by a travelling mosaicist, Felix of Puteoli, and his local apprentice Amor – an indication of how patterns and skills spread. Hellenistic subjects were increasingly augmented by these scenes from contemporary life. The late mosaics of the great villa at Piazza Armerina in Sicily which seem much influenced by North African work include all elements. There in a palatial building are stories of Hercules and Odysseus, Cupids fishing, a wild animal hunt to supply the arena, a scene of the Circus Maximus – even the owner's wife and children on their way to the bath suite. Today a walkway is provided so that the visitor can look down on the floors from an advantageous point, but this stresses the problem of viewpoint when the rooms were in use. The big game hunt in the long corridor would have been hard to appreciate beneath one's feet and seems much more suited to lining a wall. The subjects chosen for floors varied from area to area and in Britain by the fourth-century scenes from the Aeneid (Fig. 4.5) and references to Christianity had joined the repertoire.

The coloured wall mosaics that have survived are usually associated with *nymphaea* or water features in gardens and summer dining-rooms. They provided a waterproof background for small fountains and were built round the basin, often with further decorations of sea shells. The

Fig 4.5 Dido, Aeneas and Ascanius hunting; part of the mosaic from Lower Ham villa, Somerset, C. AD 350.

coloured glass *smalti* gave bright colours when wet and could be slightly angled to catch the light. They were also used to pick out details in porticoes or decorate niches and *lararia* (household shrines). A house in Herculaneum has particularly fine wall mosaics in brilliant colours, one with Neptune and Amphitryte (Fig 4.6), the other with deer. The tradition of such mosaics is continued in Byzantine and early Christian wall

Fig 4.6 Neptune and Amphitryte: wall mosaic in coloured *smalti* and shells from Herculaneum.

mosaics; the descendants of the deer in Herculaneum can be seen in the apse of the church of San Clemente in Rome.

Art or Craft?

Should we consider mosaics as art or a craft? This is the genre that is most readily associated with Rome and it seems probable that Romans did not see a distinction between artist and craftsman. The use of pattern books, the repetitive grids laid by assistants, the copying of paintings, the many versions of the same subjects all seem to support the modern view that it is a craft. If it is art, where does the artistry lie? Perhaps there is a parallel today in the term illustration which can cover anything from

advertisements to delicate pen and ink studies. Not all illustrations rank as art, nor do all mosaics.

In purely geometric mosaics we can appreciate the inventiveness in adapting and developing basic shapes, the choice of colours and the skill with which they have been laid. Even if a pattern book was used, each floor had to be recreated to meet the demands of the patron and the constraints of each space. Comparison of patterned mosaics from various regions shows how different schools dealt with awkward areas, by using framed motifs or blocks of pattern to fill an irregular shaped floor. We have an advantage over the Romans in that we see the floors with no furniture or people standing on them. When mosaics have been wall-mounted or can be viewed from a gallery – as at Lullingstone villa – it is easier to assess the overall effect, but what we can rarely see is how well the mosaics combined with the treatment of the walls.

Perhaps it is easier to class as art detailed polychrome *emblemata* and large figurative mosaics, including copies of paintings. As we have seen, originality was not so important to the Romans; they were more likely to admire cleverness. So a painting faithfully rendered in mosaic, the colours of stone so finely shaded that they seem to merge, the lines of *tesserae* resembling brushstrokes, would seem a real work of art. The *andamento* skilfully handled can produce the modelling of the figure; clumsily done in too regular lines it can make even Venus appear to be wearing a heavy-knit bodystocking as in a pavement at El Djem. The delicate use of white *tesserae* to convey highlights, the suggestion of depth, by shading and by the placing of the figures, are all artistic skills. When a mosaic has been wall-mounted the proportions of figures seem correct to us and show that generally no allowance was made to compensate for the angle of view when looking down at a floor. In the fishing Cupids mosaic at Piazza Armerina space is created by having the Cupids and their boats moving in lines rather than diminishing in size, and those supposedly further from us are the same size as those in the foreground. In the nearby Great Hunt, fascinated by the rigging of the ships, the third-century costume, the cages for transporting the animals, or the terrified hunter who has taken refuge in one himself, we can easily omit to consider the overall composition and how effects have been achieved. In a scene where three huntsmen haul a rhinoceros from the water, indicated by two-tone undulating lines of *tesserae*, the rhino's legs and underbelly are shown green as are those of the hound that swims towards it. Some further figures are partially obscured by the nearer but even in this fine mosaic the problems of depth and perspective have not been fully solved.

You may consider *opus vermiculatum* with its delicate shading as the peak of mosaic art and rate polychrome figurative work above black-and-white. However the vigour and movement of black-and-white designs like those of the Baths of Neptune in Ostia have more claim to be art than some detailed coloured scenes with stocky figures, identical faces and unimaginative *andamento*. *Andamento* can enhance a design by conveying the moulding of a figure, or be used in laying the ground to emphasise shape or movement. Nor should we judge only by the size of the *tesserae*. Quite large pieces compose one of the most pleasing mosaic scenes: it shows Dido, Aeneas and Ascanius in a spirited hunt and is part of a floor illustrating *Aeneid* IV from the villa at Lower Ham in Somerset, now in Taunton Museum (Fig. 4.5). To help in forming a judgement there are less expert and yet attractive figured mosaics that survive from third- and fourth-century Britain, e.g. Romulus and Remus with the wolf in Leeds City Museum. These may help to distinguish between what is owed to skill in mosaic technique and what to artistic imagination.

Chapter 5
Silver and Bronze

Republican and Early Imperial Silver

Silverware was very highly prized by the Romans. The conquest of the Hellenistic kingdoms of Asia Minor had brought large quantities of richly ornamented cups and bowls to Rome and these changed hands for enormous prices. Verres amassed so much gold and silver plate in his iniquitous plundering of Sicily during his governorship that Cicero tells us he established a workshop to enrich bowls with decorations removed from other objects (*In Verrem* II iv 54). These bowls and plates with portrait medallions or mythological figures projecting from them in such high relief that they cannot have served any functional purpose were for display and were shown off on a sideboard, which might itself be silver. Such show plate was among the 109 pieces of silverware the excavators found hidden in the villa at Boscoreale near Vesuvius. One display bowl with foliar patterns on the rim bears a high relief figure personifying Africa who wears an elephant head-dress and is awkwardly surrounded by other animals. Because of silver's intrinsic value, much republican and early empire silver was melted down as the Roman empire in the West fell. The hoard discovered at Boscoreale and another of 118 pieces in a wooden chest in the House of the Menander in Pompeii give some idea of the amount of silver that prosperous men of their time and area would have owned. The amount owned by the really wealthy must have been staggering. Even Martial, not a rich man, thought he was reasonable in expecting four pounds of silver as a New Year's gift and complains when all he received was a silver snail pick (*Epigrams* VIII 71). Petronius' self-made Trimalchio was so proud of the value of his silver that he had his name and the weight inscribed on it, and boasts in his ignorance of the bowl decorated with a scene of 'Daedalus enclosing Niobe in the Trojan Horse' (*Satyricon* 52). Exaggeration of course, but excesses existed outside fiction and Pliny mentions Pompeius Paulinus who took 12,000 pounds of silver plate on campaign in Germany (*Nat. Hist.* XXXIII.144). The decoration of much silver is of such high quality that there must have been a demand for expert work, not merely for impressive weights.

The Augustan themes from the Ara Pacis were favourite decorative subjects as were mythology, nature, vines and, of course, Bacchic revelry. Two cups from the first century BC in the British Museum have an elegant raised design of scrolled foliage with birds and flowers. One of the cups from the House of the Menander features sprays of olive leaves with the berries fully moulded (lead-filled to give them body).

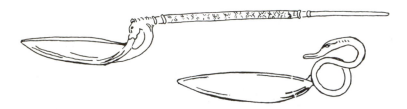

Fig 5.1 *Cochlearia* and *cycnus* spoon styles from the Thetford silver horde, 4th century AD.

Such a cup was part of a set of silver vessels, known as a *ministerium* which consisted of table silver (*argentum escarium*) and *argentum potorium* for drinking. These silver services were for use in the dining-room of the well-to-do, where guests could admire the craftsmanship. Included were bowls of all sizes, sometimes fluted with incised patterned ribs, sometimes with acanthus leaves moulded on the outside, *lances* (tray-like platters), bowls shaped like shells for fish dishes, pepper-pots and spoons, which were the only cutlery used. The style of spoon changed over the centuries from round bowls with patterned handles to *cochleariae*, originally for eating snails, with oval bowls decorated at the joint of bowl and pointed stem, while *cycni* had coiled swan-neck handles (Fig. 5.1).

The silver for drinking was comprised of ladles, strainers, amphoras, jugs and cups of many shapes. Some of the cups of the straight-sided bowl shape known as *scyphus* are heavily embossed with figures; one from Boscoreale shows barbarians submitting to Augustus. Such a choice of subject might imply a desire by the owner to impress with his patriotism, a reminder of military service or an imperial gift. As in all varieties of Roman relief work the modelling is very fine on this prestige item, though perhaps the two-handled goblet shaped *cantharus* decorated with cranes, from the same site, is more elegant. The hammered *repoussé* patterns (worked from reverse into relief) might be combined with chasing and swirled with arabesques of vine leaves and flowers, reminiscent of the designs on the Ara Pacis. Cups with *repoussé* patterns on

the outer shell were often soldered to a more practical smooth inner lining with a rim and handles and set on an annulated foot, i.e., a circular base decorated with tapering concentric rings. Gold was used to enhance the relief decorations to produce, for example, a silver cup adorned with gilded vine leaves. Lucullus who, according to Plutarch, had displayed in his triumph 52 litters of gold and silver captured from Mithridates, used even more luxurious cups studded with jewels. When such cups were in use, Juvenal complained (in *Satire* V) that waiters were stationed to see that guests did not pick out the stones.

Jugs were used for wine and water. The plain-bodied jugs, baluster-shaped or squatter and more bulbous, had their decoration on the handle which might also have scrolled or moulded arms attaching it to the neck. Decorated jugs for dinner parties or religious rites (in Fig. 2.3a, p. 27, the attendant at far left is carrying one) have a pear-shaped body, tall neck and a high foot. The arching decorated handle was cast and the body and neck adorned with figures from mythology or scenes of sacrifice. What could be more suitable for a gathering of cultured friends than silver bearing scenes from Greek tragedy? Silver amphoras, not to be confused with the large clay storage containers, were small two-handled spout-less vessels. Decorated with scrolling vines they were for table use, but a number were found at Aquae Apollinares, the spa north of Rome, offerings by visitors hoping or giving thanks for a cure. The handles of ladles and *paterae*, the silver vessels shaped like saucepans, offered scope for decoration. Whereas ladle handles are shaped and patterned in similar styles to ornate nineteenth-century cutlery handles, the broader flatter handles of *paterae* have space for more elaborate work. They were cast in low relief with miniature figures and animals, and the design extended along the arms which attached them to the round bowl of the body. As the different imagery suggests, these too were used for drinking parties and for religious rituals. There are examples of acanthus and vine leaf patterns, Cupids, Mercury, Minerva, Neptune and arms in scroll-work or shaped as swans – so many designs that one can imagine Romans collecting them. Large dishes with figured medallions in the centre and rims with incised patterns may have been used for sacrificial meats, banqueting or for display.

Silverware was not restricted to the dining-room and altar. In houses furnished with silver tripods to support trays, silver candelabra and silver embellishments to the scrolled ends of couches, ladies would use silver jewellery boxes, oil flasks, wash-basins and tiny implements decorated like jewellery. Most important were silver hand-mirrors; the face was polished to give a good reflection and the reverse decorated with designs

engraved or in relief. The back of a mirror found in the House of the Menander has a striking portrait-head in high relief. Handles were long and shaped as balusters or twined tendrils and the rims further decorated with pierced patterns or projecting cusps. Mirrors became small works of art and a possession of status, as illustrated by the many representations of Venus in reliefs, mosaics and paintings where an attendant Cupid holds up her mirror.

The demand for silverware seemed insatiable and silversmiths met it by increasingly casting objects and working from moulds. Pieces could then be further embellished by hand with chasing, or engraved with patterns of concentric circles. It is quicker to work by cutting and stamping rather than hammering, but heavier alloys are needed and this method was rapidly adopted (PLINY, *Nat.Hist.* XXXIII 125). Another popular form of decoration was *niello*, the work in which black metallic sulphide is inlaid in parts of a design, often contrasted with other parts gilded with gold leaf.

Later Roman Silver

By the middle of the third century so much silver and gold was held in the form of luxury objects in the houses of the wealthy and in temple treasuries, and hoarded in times of political uncertainty, that it was lost to the economy. Not surprisingly, little work in silver dateable to this period has been found, except in Gaul where political insecurity seems to have led to the burial of hoards like that from Chaource – now in the British Museum. With a shortage of bullion the coinage was progressively debased and prices, wages and taxes were in chaos. Recovery was gradual. Diocletian began the improvement with his price-fixing policies, but it was not until the period of stability under Constantine that the Romans began to acquire splendid collections of plate again. The silver and gold of the third and fourth centuries is strictly outside the range of this book, but as so much impressive later silver has been discovered, or is on display, in Britain it seems a pity not to include it. Some of the pieces reflect the recognition of Christianity by Constantine and symbols like the *Chi Rho* are found along with the traditional mythological decorations.

There was a new era of prosperity in the fourth century that had encouraged spending on luxury goods and it is ironic that the barbarian attacks that menaced the Roman Empire on its northern and north-eastern borders in the fifth century should have preserved so much Roman silver for us to appreciate. Threatened by raids or invasions, wealthy families

buried their valuable collections of silverware and clearly many did not survive to recover them. The largest numbers of hoards have come to light in Northern Europe and the Danube provinces. The Thracian treasure from Rogozen in Bulgaria contained 165 silver and gilded vessels, mostly *phiales* and jugs. These resemble the first-century jugs in shape but are somewhat heavier. The decoration ranges from simple

Fig 5.2 The great dish from the Mildenhall Treasure, 60.5cm. diam.; only the head and shoulders of the supporter of Hercules at left are shown, but the rhythm of the figures is so strong that this goes unremarked.

bands of engraving to heavy gadrooning (bold vertical ribbing), in some cases picked out in gilt, and jugs richly embossed with mythological figures, again sometimes enhanced with gilding.

In Britain the major finds of Roman silver and gold have been in areas exposed to attack from the North Sea. At Taprain and Thetford hoards consisting of damaged gold or silver and other pieces intended for reworking, which were buried by silversmiths, have come to light. Presumably the owner buried the great hoard found at Hoxne in Suffolk, possibly

Aurelius Ursicinus whose name appears on a set of spoons. The wooden box contained, besides 15,000 gold and silver coins, 150 items including gold jewellery and silver toilet items, bowls, spoons, even a silver gilt pepper-pot shaped like the bust of an empress. The Mildenhall treasure found in Suffolk in the 1940s consisted of bowls, spoons – some with inscriptions in the bowls – a larger bowl with swing handles and foliar designs engraved between the fluted ribs and with a pattern of interlaced triangles in the centre. The pride of the collection is the great plate 60.5cm. in diameter which, like its two smaller companion pieces, shows a *thiasos*, or group of Bacchic revellers (Fig. 5.2). In the centre is the head of Oceanus surrounded by a band of marine revellers enclosed in a border of shells. Dionysus with his attendant panther is surrounded by dancing nymphs and satyrs, two of whom support a drunken Hercules. One of the supporters grasps Hercules firmly under the arms but, when you look closely, he himself has no body or legs. Such is the rhythm and vitality of the dance that this is rarely noticed. The two smaller plates have each a pair of dancers and all three have the heavy beaded rim that is a feature of later silver. The swirl of the draperies and the vigorous poses of the dancers in beautifully modelled relief are in different mood from another important find of fourth-century silver, the Corbridge *lanx*. This large display piece was found by a small girl in the river bank at Corbridge, Northumberland in 1735. Tray-like in shape with a meander-border of vines it has a much more static scene depicting Apollo and other deities at a shrine; it is one of the outstanding pieces of late silver. Large platters also feature in the Kaiseraugst treasure from Switzerland; one with an apse-like projection at each end must be meant for serving fish as it has a scaly example in the centre.

Statues in Silver

This hoard also included another example of silver-work, a statuette of Venus, while at Mâcon eight small statuettes of deities were found. Although we read of emperors commanding, or forbidding, statues of themselves in gold or silver, full-scale statues are more likely to have been in gilded bronze (SUETONIUS, *Domitian* XIII 2). The examples that survive are these small-scale deities, made for dedication at temples in fulfilment of a vow or for use in the *lararium*. They stand on small bases, usually circular, and the poses are similar to those of full-size statues. The New Testament story in *Acts* 19 of the silversmiths of Ephesus, who rioted against St Paul fearing loss of their trade in figures of Diana, suggests that these statuettes were often copies of cult statues. Examples

of miniature portrait-busts of emperors in precious metals have been found – one in gold of Antoninus and one in silver of Lucius Verus – but they were also made for private citizens to whom they must have seemed the ultimate expression of wealth.

Bronze

Bronze statuettes of the gods of varying quality can be seen in most museums: they range from graceful figures like the Colchester Mercury

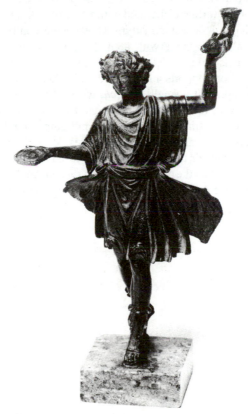

Fig 5.3 Bronze figurine of a dancing Lar; such statuettes were finely modelled even though produced in large numbers.

and the little dancing *lares* with swirling skirts (Fig. 5.3) to poorly moulded copies of statues of the gods. These, like the small bronze models of animals, may well have been produced to serve as votive offerings. Many of the luxury items produced in silver were also made in bronze.

The vessels for table and sacrifice all exist in bronze versions and some have their bodies decorated in similar fashion, but in general the decoration of jugs and *paterae* is concentrated on the handles. Bronze was not necessarily the poor relation however; it was used when strength and durability as well as ornament was required and was sometimes inlaid with silver.

Bronze was of course used for many things besides vessels and statuary. Strigil handles could be engraved with scenes of the circus. The bronze *fulcra* (curving ends of couches) were decorated with horses with arching necks and further elaborated with silver or ivory. Bronze tripods were given legs of fantastical satyrs. Unexpected combinations were enjoyed, so tall lampstands with arched tripods on animal feet have naturalistic stems from which leaves seem about to sprout. A stout Silenus on a tripod supports a lampstand on his head. The lamps themselves might represent a small *aedicula* with a figure of Jupiter and a hound curled at his feet. Others came in the form of a sandalled foot or a reclining figure. A small bronze table from Pompeii has horse-headed legs that curve extravagantly to neat hooves. Bronze decorations for harness and chariots or the wolf heads that cased the ends of beams on imperial ships all show the desire for decoration and the skill in supplying it. Even the bronze weights for steelyard scales were modelled as heads of gods or portly satyrs.

Chapter 6
Decorative Arts

Jewellery

Under the republic there were restrictions on the wearing of jewellery. Gold rings were a mark of rank, and originally the privilege of nobles and *equites*; they might also be awarded as military decorations. In times of national crisis Livy tells us how Roman women voluntarily sacrificed their gold jewellery to the treasury and during the Punic Wars by the *Lex Oppia* they were restricted to half an ounce of gold each. There must have been women who owned fine pieces from the skilled Etruscan workshops but the impression is of jewellery more valued as gold than for its craftsmanship. In the Roman comedy-writer Plautus' *Mostellaria* (288) the courtesan's old attendant tells her that jewellery is only 'for making an ugly female more presentable' and advises her against wearing any at all. But it was the public protest of the women that brought the repeal of the *Lex Oppia* in 195 BC and, by the time of the empire, austerity was a thing of the past. As wealth increased so did the taste for display in all ranks of society. Juvenal mocks the rich women in emerald necklaces, their ears laden with pearls, as well as elderly whores in thin gold neck chains (*Satires* VI 458, 589). Martial writes exaggeratedly of a man with six rings on each finger, and in Petronius' *Satyricon* (67) Trimalchio boasts that his fat wife, Fortunata, is wearing six-and-a-half pounds of gold in her twisted anklets and bracelets.

Designs for all jewellery were developed from Etruscan and Hellenistic styles, although there was less use of granulation and filigree in Roman work. Necklaces of many kinds survive, from the strings of simple beads and link chains of varying weights to elaborately crafted chains made by the loop-in-loop technique. We have not only surviving necklaces but the coffin portraits from Roman Egypt to show us how they were worn, often several at a time (Fig. 6.1). In the first and second centuries AD chains were worn with crescent pendants, sometimes with finely decorated finials, and wheel-shaped clasps, perhaps symbolic of sun and moon. Other chains have larger gold medallions or a single gem set in a gold collet in the centre. Precious stones such as emeralds and amethysts were also set in collets and interspersed with quatrefoil or *pelta*

(shield-shaped) links of gold to form the most luxurious necklaces. This type of setting allowed for the translucence of the stones to be appreciated and emeralds in their natural hexagonal shape were strung as beads with gold links between. The Greeks and Etruscans made gold collar-like

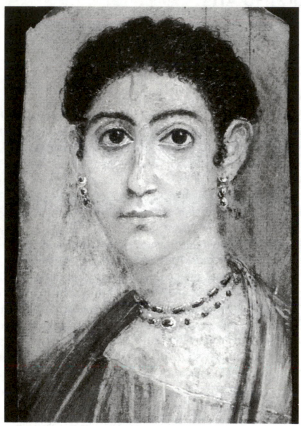

Fig 6.1 Encaustic portrait of a woman from Hawara AD 100-120. She wears gold hoop earrings set with emeralds, an emerald and gold necklace and a second necklace of small amethysts and gold, with a large gold mounted emerald in the centre and two pendant pearls.

necklaces of fine chains with many small pendants of fine craftsmanship, but these were rarer in Roman times. Some of the most delicate workmanship can be seen in earrings. Apart from the 'everyday' gold disc-and-ball earrings which somewhat resemble blackcurrants in shape, there were three other popular types. Hoop earrings were occasionally plain but more often threaded with small pearls or other gems; small pendant earrings had a pearl or gold bead suspended on gold wire. The most

elaborate style had a rosette or gold-mounted stone with a small bar below, from which hung two or three small pendants of pearls, stones and gold beads. Pearls were enormously popular. Pliny tells of women with so many pearls in their earrings or stitched to their clothes and sandals that they jingled as they walked (*Nat. Hist.* IX.113).

Bracelets are found in two main styles, the rigid hoop or the chain

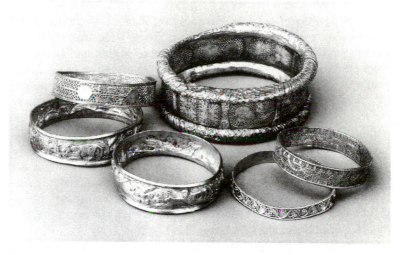

Fig 6.2 Bracelets from the Hoxne hoard, 4th century AD; the narrrowest has granular decorations, two are in repoussé work and three in lacy *opus interrasile*.

style. The latter were made with double rows of small gold balls or decorative links of intricate craftsmanship, sometimes interspersed with semi-precious stones such as plasma (a green chalcedony). Hoop bracelets, usually of gold, seem to have been worn on the upper arm, to judge from paintings and the rare sculptures that show jewellery. These hoops might be plain or twisted with decorative finials or with a single mounted stone. Serpent bracelets, popular in the Hellenistic world, were worn in the first century AD; an example in the British Museum has the snakeskin rendered by hatching and a detailed head. In 1992 a staggering nineteen solid gold bracelets were unearthed at Hoxne, Suffolk, and provide us with a range of examples of the goldsmith's art (Fig. 6.2). There are *repoussé* designs of bands of animals beneath shining everted rims. On one a big cat stalks a fiercely horned wild goat. Another style has a meander-pattern in gold wire with sprigs of granular berries between granulated borders. This technique of soldering minute pellets of gold to form patterns had

been popular with the Etruscans and it is surprising to find so late an example. From the second century AD Roman goldsmiths had been making jewellery in a kind of gold fretwork known as *opus interrasile* and there are bracelets of this style, made by punching out the design, and also openwork ones where motifs have been superimposed on a filigree of gold wire. One very broad bracelet has stamped patterns combined with *opus interrasile*.

Gold rings, as we have seen, were a sign of status but decorative rings were also worn, apparently by both sexes. These were often similar to modern rings with large circular or oval stones set in gold, and decorative work on the shoulders. When rings were made of *opus interrasile* the gold was heavier than in the bracelets and the design is often composed of letters. An example, found by a man hoeing turnips and now in Newcastle University Museum of Antiquities, reads AEMILIA ZESES – 'Long live Aemilia'. However, the greatest artistry of all was shown in the engraving of gemstones which might serve a dual purpose as jewellery and signets. From republican times intaglios in stones such as cornelian and onyx were worked with bow-powered drills. These miniature carvings show great mastery of design and detail in representing mythological subjects or personal devices for rings to stamp a document in place of a signature. Suetonius says that on his first signet ring Augustus had an engraving of a sphinx, changing later to a head of Alexander, then a portrait of himself by Dioscurides (*Augustus* 50).

In the reverse technique of cameo-cut gems there was a tradition of honorific state cameos dating from the time of Augustus, probably carved by Greek gem-cutters. Their use is unclear though their message is not. In the sardonyx cameo of Augustus now in the British Museum, Augustus is shown in profile wearing the Medusa-head breastplate of Athena. The refined handling reflects the neo-classicism he favoured. This is also apparent in the Gemma Augustea, now in Vienna, where Augustus is seated beside the personification of Rome amid symbols suggesting power and even divinity, while in the lower register is a more realistic scene of soldiers erecting a trophy of arms amid their barbarian captives. The composition and carving is particularly fine, especially in the moulding of the bodies. The Great Cameo in Paris shows Tiberius with similar symbolic figures but is less finely carved. This skill – producing an image against a contrasting background by carving away an outer layer – we shall find used again in glassware.

Glassware

The qualities that mark out glass as exceptional today are clarity or sharpness of cutting or etching, striking new shapes or subtle clouding, colouring and texture like the work of Lalique. The heavy cinerary urns with ribbon handles or chunky beakers which occur in most local Roman collections do not strike us as works of art. However, these dulled and weathered iridescent items should not prejudice us against looking at the more sophisticated examples any more than familiarity with chainstore tumblers stops us appreciating Waterford crystal. Like so much else, what is described as Roman glass originated in the East. Glass-blowing was developed in Syria and Alexandria to produce everything from the utilitarian to collector's items. The different techniques of glass-making, casting, blowing and hand-finishing or blowing into moulds, using coloured canes, grinding, polishing, cold cutting, were all in use in the Roman period and then lapsed until their revival by the Venetians. From the first century BC glass was in demand for its practical as well as decorative qualities and workshops were established in many localities in the Western empire.

Again the importance of dining influenced what was produced and, at first, glass tended to follow the accepted shapes of its silver or bronze

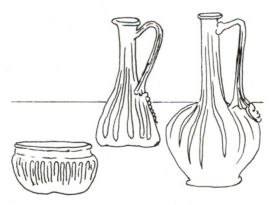

Fig 6.3 Styles of Roman glass; one jug handle decorated with a medallion, the other with glass pincered to form ruching and both decorated with slip-trailed ribs. Ribbed bowls were mould-blown.

counterparts, but soon developed its own forms of decoration. Long-necked jugs used for serving wine developed particular styles. Necks were decorated with trailed spirals; the tall arched handles, sometimes in a contrasting colour, were finished with a medallion or ornamented with an

applied strip, crimped while still molten, to give the appearance of ruched ribbon (Fig. 6.3). The body could be ribbed, diagonally fluted or swirled with coloured trailing. The Roman philosopher Seneca's comments on the glass-blowers' skill in shaping by breath alone suggest that Romans appreciated the variety of shapes that were produced (*Epistulae Morales* XC 31). Pear-shaped, conical, flared or tapering, there were many more variations of shape in glass jugs than in silver and bronze. Glass was also appreciated for its sparkle and transparency; it was frequently used in literature for comparisons with water: Horace describes the fountain of Bandusia as 'more brilliant than glass' (*Odes* III 13.1). Painters too enjoyed the challenge of rendering glass and added glass bowls of fruit on *trompe l'oeil* shelves to wall-paintings.

Cameo glass was also one of the achievements of this period, using the same technique as in cameo jewellery. The surviving examples were made by casing dark blue glass with a layer of opaque white, which is then delicately cut away to leave beautifully detailed figures in white against the blue ground. The most famous example of this technique is the 'Portland vase' in the British Museum, which is thought to show the wedding of Peleus and Thetis (Fig. 6.4). In the Naples Museum there are some cameo-glass panels of Dionysiac scenes and a wonderful vine-covered amphora with Cupids harvesting the grapes. In another over-lapping of genres small glass sculptures were produced, including a head of Augustus. These appear to have been cast in moulds and then the finer details cut before polishing.

The method of blowing molten glass into a mould meant that vessels could be produced with relief designs similar to silver or Arretine pottery (see *Ceramics*, p. 82). A deep blue, ribbed, mould-blown two-handled cup with a scrolling vine border was signed by an artist Ennion. He seems to have moved to Northern Italy from the East in the first century AD, as another of his works is an elegant amber-coloured jug with a shaped derived from silver but a pattern designed for glass. Light or yellowish green drinking-cups, blown into moulds, are similarly shaped to silver cups with heroic reliefs, but in the glass versions there are bold designs of chariot-racing and gladiators – themes suited to a wider market. Novelty jugs and flasks were made with a head or even a monkey for the body, with the neck improbably imposed on the top of its head. Perfume bottles were produced in the form of small animals or unusual things like a pair of sandals.

Mosaic glass, where preformed canes of multicoloured glass are used, was chiefly associated with the Alexandria workshops. These canes might be used to deposit coloured 'gems' on to clear or opaque glass for a vase

or beaker, or fused into shape in a mould and then polished to make multi-coloured bowls. Another style featured ribbons of coloured glass twisted and fused to produce, for example, a scent bottle in diminishing stripes of white, yellow and dark blue. According to Pliny the most highly valued and expensive glass was colourless transparent glass intricately

Fig 6.4 The Portland vase; the layer of white glass has been cameo-cut to reveal the blue glass below.

decorated (*Nat.Hist*. XXXVI 199). This was probably cast glass made at the end of the republic and in the early empire, before demand brought the change to mould-blown glass, which was quicker and cheaper to produce. Both cast and blown glass was wheel-cut to produce a variety of effects. Faceted jugs and beakers were cut, then ground to give a honey-comb or diaper (an all-over diamond-pattern) surface to the whole body

to contrast with a plain rim and foot. Mythological scenes were engraved or cut onto bowls, using many parallel straight wheel-cuts to represent shading or foliage; the figures on these are much like intaglios.

Late Roman glass included works with designs cut in gold leaf and sandwiched between two layers of clear glass to produce portrait medallions. These and roundels containing symbols or small scenes were used for the base of bowls and cups. The subjects are often Jewish or Christian. In the fourth century an intricate new style of luxury glassware was being produced known as cage-cups (*diatreta*). The vessels appear to have a fine outer network of linked circles attached to the body by small bridges and similarly raised letters, wishing the drinker long life. In fact the cage has not been attached but created by cutting away from a thick blank, leaving only the small bridges. The most spectacular work in this technique is the cup in the British Museum which tells the story of Lycurgus. He and the vines that trap him, held by tiny bridges, stand clear of the greenish glass which turns dramatically to red in transmitted light.

Ceramics

Roman ceramics do not rival translucent Chinese porcelain or delicate painted Worcester china, but besides the tough workaday clay pots there were the Arretine red-gloss cups and bowls that were embossed with patterns and figures. This ware was produced at Arezzo from the first century BC and was made from iron-bearing clay which was dipped in a special solution of fine clay before firing to give a glossy red finish. For everyday use there were patternless plates, bowls and cups, but once again we see the importance of dining on the arts. Richly decorated items were produced as a more affordable alternative to silver tableware and it seems possible moulds for these bowls and cups were sometimes obtained from silver vessels. Moulds were made in wood or heavier clay and might produce the whole design, or small figures and animals could be moulded separately and attached before dipping and firing. The bowls come in a variety of shapes, but most offer a vertical and a sloping exterior surface for decoration which often includes the potter's name. The wares were relief-moulded with patterns influenced by Hellenistic designs of naturalistic trails of flowers, large leaves and medallions and continued with the Augustan themes of peace and plenty expressed by the abundance of nature. Figure designs followed with bands of dancers, the vine harvest, feasting diners and pairs of lovers, as well as chariot races and warriors.

In the early empire well-to-do provincials began to demand this cheaper but attractive red-gloss tableware and potteries were established in many parts of the Western empire. In the first century AD pottery from Southern Gaul became very popular and was imported into Italy. A case of such pots was found unopened in an earthenware shop at Pompeii. Designs were normally on the outside of the bowl but in the Cologne

Fig 6.5 Red-gloss ware bowl with Orpheus and the animals.

museum there is a splendid bowl decorated on the inside which must have been for display. In a design familiar from mosaics Orpheus plays his lyre beneath a tree, surrounded by innumerable animals (Fig. 6.5). The elongated animals suited the shape of bowls and appealed to a clientele whose chief sport was hunting. On a bowl from Gaul, with the stamp of Butrio, horsemen and hounds realistically pursue deer and boar in a leafy wood beset with snakes. A particularly pleasing jar in the British Museum has sinuous slip-trailed stems with leaves moulded and applied and a spirited greyhound leaping for a ball among them. In contrast the African red-slip pottery from Tunisia is much more closely derived from metalware. Jugs with scenes of dancing in higher relief or bowls with

moulded motifs attached to broad rims resemble similar vessels in silver. The Romans also used other forms of decorated pottery, painted, colour-coated, and the coloured lead-glazed wares which we associate with the word pottery today.

Gardens

Garden design is one of the most fleeting of arts, soon destroyed by a few decades of neglect, but advances in archaeology and palaeobotany have made it possible to learn what the gardens that were an integral part of a town house were like. Pliny the Younger described the gardens of his villas in Tuscany and Laurentum mentioning fountains, box and rosemary hedges, topiary figures, vine pergolas, courtyards shaded by plane trees, screens of box and laurel, and vine-shaded outdoor dining areas (*Letters* II.17 & V.6). Ivy was used in mounded tumps or to clothe buildings. Cicero comments that his brother's 'landscape-gardener has draped everything in ivy, walls and the columns of the walk, to such an extent that those Greek statues of yours seem to be setting up as garden designers and selling ivy' (*Ad Quintum fratrem* III.1.5). All these features seem to have existed on a small scale in the peristyle and small rear gardens of houses in Pompeii and Herculaneum. Soil analysis, root cavities, sunken pots, and planters confirm that the varieties of plants shown in wall-paintings were all growing in the garden too. The *viridarium* was essentially a garden for pleasure, a further space in which to display one's cultured taste, and though it might be planted with fruit trees it was distinct from the *hortus*, the fruit and vegetable garden.

To provide coolness and shade the garden might be informally planted with trees and shrubs or laid out to a more formal plan, with beds outlined in brick or stone or clipped hedges as in the House of the Golden Cupids at Pompeii. Formal designs were often focused on water, either fountains that rose from pools or decorated basins on pedestals. Pools might be circular, rectangular, or shapes broken with apsidal recesses. A narrow canal, or *euripus*, might serve the dual purpose of ornament and irrigation. A rectangular garden at Conimbriga in Portugal has such canals, piped on each bank to provide rows of fine arching jets. The garden of Loreius Tiburtinus in Pompeii combined T-shaped canals with a vine-covered pergola, to shade his terrace and lead down the garden with a series of mini-waterfalls and *aediculae* containing fountains, all trellis-framed. The terrace was further enhanced with statues and outdoor dining couches beneath paintings of Narcissus and Thisbe discovering Pyramus. Conspicuous display was not confined to inside the house.

Other gardens featured mosaic fountains, set with bright coloured *smalti*, where the water splashed down small marble steps or fell into a little pool. Many gardens were adorned with animal sculptures, stags, boar and hounds, as well as mythological characters. Marble reliefs, either a rectangular panel, frequently of a Dionysiac scene, were displayed on pillars, or thin circular decorated discs (*oscilla*), could be suspended between the columns of the *peristylium*. In many houses the *lararium*, or family shrine, was located in the garden and often decorated with painting.

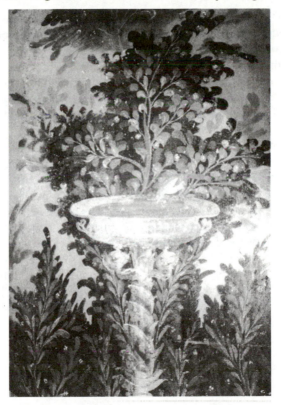

Fig 6.6 Garden painting of fountain and birds from the Villa of Oplontis.

As we saw in Chapter 3, the walls of the *peristylium* or the rear walls of smaller gardens were often painted with garden scenes. At Oplontis there are two small courtyard gardens with panels like windows showing fountains set among oleanders and myrtles (Fig. 6.6). In Pompeii the walls of the *peristylium*, which was often quite small, were similarly treated to give an illusion of distance either with paintings of recognisable plants

or a view of a park with wild animals – as in the House of Julius Fronto. However the most frequent choices were fountains with perching birds and fruit trees growing among flowers. The painted garden usually had a trellis fence or low wall in the foreground to mark the boundary of this magical extension of the *viridarium*, a garden that was always in bloom and filled with birds.

Art in Everyday Life

'Commercial artist' is not a term normally associated with the classical world, but art can be taken to include all the designed and decorated items that surrounded the Romans in their daily life. That textiles were decorated with woven designs and embroidery we know from a relief of a shop scene, from Ovid and from Catullus' description of the cover of Peleus and Thetis' couch (CATULLUS, LXIV 50). The terracotta lamps that were produced in thousands were decorated with everything from erotic scenes to religious symbols. The terracotta antefixes decorating gables might feature palmettes or Medusa heads, and revetments (facings along the upper part of walls) be patterned with acanthus leaves, or even figure the struggle of Antony and Octavian as a contest between Dionysus and Apollo. Terracotta figurines range from figures for use as votive offerings which include gods and goddesses, parts of the body and animals, and examples that must be tourist souvenirs and toys. Larger figures, like the Muses in the British Museum with their crisp lines, decorated gardens. Shops had painted signs or signboards in relief with vignettes showing, for example, women in a poultry shop with live rabbits on sale. Many of these items display a lively sense of humour and all show that Romans of whatever level of society took pleasure in the visual arts.

Chapter 7
Art and the Romans

There were so many strands to Roman art – the traditional desire to record things as they appeared, whether in portraits, relief or painting; the enjoyment of conspicuous display, the admiration of all things Greek, and the desire to imitate the Greek and Hellenistic works that came to Rome through conquest and trade. Yet the works they inspired manage to combine into a recognisable whole wherever they are encountered. In addition to traditional Roman forms, Greek and Hellenistic art reached a wide audience as victorious generals put captured works on display, and great collectors like Asinius Pollo proudly showed their treasures. Magistrates too would organise art exhibitions at festivals. In the first century BC, as well as producing Greek-style art for his Roman patrons, the sculptor Pasiteles wrote on art and helped to guide taste, particularly among the nobles, so that two lines of style developed and so-called plebeian taste continued to favour republican models.

Yet even this traditional taste was gradually modified by the tremendous programme of public art initiated by Augustus and the neo-classical styles that he favoured. In an age without printing or universal literacy he exploited the power of visual images to invent his own myth of the godlike ruler in a new Rome. The motifs that he had used to emphasise the victory of Actium, like ship's prows and dolphins, the symbols that showed his devotion to Apollo – tripods, lyres, and wreathes of laurel – and his claims to divine ancestry which introduced Cupid into Roman sculpture, all became part of the language of Roman art. The Ara Pacis had conjured up the idea of a new Saturn-like Golden Age and a return to simple piety, so the bounty of nature, the *bucrania* (bull-skulls), garlands and libation bowls that symbolised festival sacrifices, all appeared in private decorative schemes as Augustus' rule continued. This is not surprising considering his regeneration of Rome after so many decades of civil war and neglected administration. What is perhaps more surprising is that these motifs continued to appear on private works under emperors whose age was less than golden. Seemingly the Roman feeling for the appropriate had decided which symbols were suited to an altar, a sarcophagus, a frieze, a mosaic or painting, and adapted accordingly. On

a sarcophagus the Victory from the spandrel of a triumphal arch becomes the Cupid supporting a shield, and a battle scene an allegory.

The Romaness of Roman art did not depend on the ethnic origin of the artist but on the treatment of the subject. In their sculpture we can see the Roman ability to borrow from the Greeks and Etruscans, adapt and make something peculiarly their own as they also did in their literature, engineering and architecture. In Latin literature echoes of Greek authors were considered to show appreciation and learning; Romans probably did not value originality as much as it is valued today, when it often appears to be the chief consideration in making art awards. Vitruvius included an art gallery in his specification for a gentleman's house and, as art began to be valued as an investment more than a record of family achievements, copies of acclaimed works would be a natural choice for those who could not afford originals. Today the artist's name is often what gives a work its value, and the limited number of named artists known to have worked for Roman patrons may reflect some uncertainty in matters of taste. It was safer to commission a copy of a statue by Lysippus than buy the original work of an unknown artist. This may be the reason that there seem to have been so many versions of the same ideas and little work that was the result of an artist's creative urge. The patron's wishes had to be considered and it is significant that though the Orpheus mosaic in Paphos is signed 'Pinnius Restitutus made me' it actually means that he commissioned it.

Roman adaptation of sculptural reliefs does show much more originality. Where a Greek frieze might show the dramatic moment in the combat of Greeks and Amazons with few figures and no attempt at setting a scene, Roman relief developed differently. The subjects were taken not from mythology but from their own history, real or legendary. The frieze of tales from early Rome on the Basilica Aemilia and the panel of Mettius Curtius on horseback plunging into the swamp both date from the first century BC. Relief suited the Roman desire to record national or personal events; by the first century AD scenes of the emperor performing a sacrifice or addressing the people became set pieces in public reliefs, but particular events were recorded in detail too. The development of narrative relief sculpture and spatial depth that are seen at their best in Trajan's column are Roman achievements. Their relief work in other areas – silver, cameo, and terracotta – is equally outstanding, as though many artists were more at ease here than with free-standing sculpture.

The Romans' vigorous animal sculptures must be the exception here. Their appreciation of the natural world, which may have derived from their roots as yeoman farmers or the pleasure the wealthy took in their

country-estates, appears again and again. The poet Horace intended his comment that 'you can drive out nature with a pitchfork, but she will keep coming back' (*Epistles* 1.x.24) literally, but it seems true of Roman art as well. Birds nest amid a relief of acanthus leaves, trees dominate the tondo of Hadrian at Diana's shrine and grow on Trajan's column, a shepherd tends his sheep on a sarcophagus, hares bound round pottery cups while silver cups are clad with vines, and animals of every kind are the subject of mosaics. The scenes of idyllic countryside with misty atmospheric perspective or of gardens with bird-filled bushes are the most attractive and innovative of Roman paintings.

In the representation of the natural world artists are most clearly following what Roman writers judged the chief aim in art, realism. Horace begins his *Ars Poetica* with an interesting comparison between poets and painters and what is and is not permissible. Vitruvius declared that a painting was 'an image of something which really exists or at any rate can exist' and condemned 'grotesques and roofs supported by candelabra' and the extravagances of Third Style painting (VII.5.1-7). Pliny, as we have seen, praised sculpture and painting for their lifelike qualities, and the second-century writer on art Philostratos the Elder also accepts that the imitation of nature is the function of art. He goes on to give detailed commentaries on paintings and it appears such commentaries were often set as rhetorical exercises. The touches of fantasy, painted griffins and grotesques, or the River God that watches Trajan's realistic men cross the Danube, show another angle. We must always be conscious of what has not survived – paintings on wooden panels, wooden statuary, works in terracotta and a wider range of paintings.

What the general view of art was can perhaps be gauged by passages in literature that describe works of art (these are termed 'ecphrases'). Sometimes these are real works, like Propertius' comments on the temple of Apollo or Ovid's on the Forum of Augustus (as we saw in Chapter 2). Sometimes they are imaginary, as when Ovid likens the growth of the men that sprang from the dragon's teeth sown by Cadmus to the unfolding of the painted scene on a theatre curtain, as it gradually rose from the slot below the stage (*Metamorphoses* III 106ff.). Such passages and the sheer quantity of painting and sculpture in the Roman world not only in temples and public galleries, but in the *fora*, on the façades of buildings, in shops and bars as well as private houses, points to a real enjoyment of the visual arts. At the end of *Aeneid* VIII, Virgil seems to make Aeneas a typical Roman: after studying all the scenes of future Roman history shown on Vulcan's wonderful shield, the gift of his mother, he marvelled and, though not understanding it all, enjoyed the art.

Where to see Roman Art

The British Museum, both its Roman and Romano-British galleries and its Townsend Collection, the Louvre in Paris, the Römisch-Germanisches Museum in Cologne, the Vatican Museum and the National Archaeological Museums in Rome and Naples are outstanding. There are some Roman works in almost every Museum of standing, but to see a really representative selection it is necessary to take opportunities to travel – and it is always worth visiting the museum of any town with a Roman past in the former Empire. Treasures as diverse as the silver bowl in the tiny museum of Lillebonne in Northern France or the primitive late mosaics at Kingston upon Hull are waiting to be discovered. The following list is by no means exhaustive.

Portraits and Sculpture

There are portrait-statues and busts in most national museums in Europe. London – the Townsend Gallery in the British Museum has portraits and sculptures. Paris – the Louvre, which has the largest collection of Roman Art outside Italy is strong on Roman copies of Greek works. The Vatican has a large collection, including a gallery devoted to animal sculptures. Rome – the National Archaeological Museum, now rehoused in the Palazzo Massimo, has portraits, statues and sarcophagi. Naples – the National Archaeological Museum, has works of all kinds, including the huge Farnese Bull and the massive Hercules from the Baths of Caracalla. Many stately homes have Roman sculpture in their collections, often displayed alongside neo-classical works, which make an interesting comparison; Bowood House, Chatsworth, Holkham Hall, Newby Hall near Ripon, and Petworth are good examples. Oxford has the Arundel marbles in the Ashmolean and Cambridge a useful collection of casts of major sculptures in the Museum of Classical Archaeology, as well as a Roman collection in the Fitzwilliam. Rome is richest for reliefs *in situ*, but Roman sites and their site museums throughout the Empire from Aphrodisias in Turkey to Volubilis in Morocco provide examples.

Paintings

Isolated paintings occur in national museums, but a real study requires a visit to Pompeii, Herculaneum, the villa at Oplontis and the National Archaeological Museum in Naples. Wall-paintings discovered in Rome, including Livia's Garden Room, are now beautifully displayed in the Palazzo Massimo.

Mosaics

All the museums mentioned above have collections. In Germany the Römisch-Germanisches Museum in Cologne and that in Trier have large grid mosaics. Cirencester, Dorchester, Taunton and Verulamium Museums in England have a variety of floors from private houses. The museum at El Djem and the Bardo, in Tunisia, and the Tripoli National Museum in Libya have mosaics of the distinctive North African style. Mosaics *in situ* can be seen at most villa sites in Britain, e.g. Bignor, Lullingstone and Chedworth. There are outstanding bath mosaics at Merida in Spain. Ostia is the place to see black-and-white mosaics in their original setting. Further afield the mythological mosaics in Paphos, Cyprus, are outstanding, but the richest collection of late mosaics is at the Villa Imperiale, Piazza Armerina, Sicily.

Silver, Bronze and Decorative Arts

All the major National Museums. The British Museum has the Mildenhall Treasure and the Hoxne horde as well as other good late silver from Rome, and some stunning jewellery. The Louvre and the National Archaeological Museum in Naples have good silver displays and a variety of works in bronze. These include furniture and fittings for furniture, lampstands, tripods and animal pieces for gardens. Decorated red glaze ware appears in most collections, but is particularly well displayed and explained at Arezzo. There is fine glass of different varieties including cameo glass in Naples Museum and the British Museum; in Cologne Museum there are cage-cups of *diatreta* work.

Website

The Website *Maecenas, Images of Ancient Greece and Rome* has over 1000 photographs of art and architecture. The URL is:
http://wings.buffalo.edu/AandL/Maecenas/index.htm

Suggestions for Further Study

One visit to the Roman gallery at the British Museum or similar collection will show up the vastness of the subject of Roman art and the limitations of this book. Focusing on one particular area and discovering more about it can deepen the appreciation of all the others. A choice of further study could be made by genre, sculpture, say, or mosaics, or by theme, e.g. the treatment of a particular subject like Orpheus or military or pastoral scenes. Socio-political factors could be studied, the patronage of the arts by the 'big men' of provincial towns or the scope of imperial propaganda. The following suggestions relate more directly to the various chapters of this book.

1. *Portraiture*: What do you expect a portrait to tell you about the person? Look at as many photographs of Roman portraits as you can find and compare them with the portraits or busts of past notables that schools and colleges often display, can you read their characters from them? Which style of sculpture produces the best portraits? Roman emperors tried to promote an image of themselves by the way their statues were carved. How does a leader create an image today?

2. *Sculpture*: Until it was discovered to be a copy the Apollo Belvedere was a most highly regarded statue. Does the knowledge that something is a copy make a difference to one's appreciation of it? Look at the two versions of Venus Genetrix; how do they differ? *Greek Sculpture and Roman Taste,* by Cornelius C. Vermeule, has several other comparisons of copies of the same originals. Read Pliny the Elder, *Natural Histories* XXXIV 15-84 and XXXVI 12-43, to discover more about Roman attitudes to Greek sculpture.

3. *Relief:* Look at *The Story of Greek Art* by Gisella A.M. Richter and *Etruscan Art* by Nigel Spivey, or similar books, and study the Greek and Etruscan reliefs. Consider how perspective and depth are dealt with. How do Roman reliefs differ? What does the introduction of mythical figures or personifications into scenes of real events contribute?

4. *Sarcophagus Reliefs*: What do you think should be shown on a funerary monument? What are the problems with art as allegory in this area? Go into a large old church or cathedral and consider what is represented on the memorials there.

5. *Painting*: Truthful representation should be the inspiration of art according to Roman writers. Do you agree? Is Roman painting more successful when it follows this ruling or when fantasy creeps in? Can paintings that are intended to create an illusion (for example that a wall is 3-D) be called a truthful representation? Read Horace *Ars Poetica* and see if you agree with his comparison of artists and poets. Do contemporary fashions in art make it harder to appreciate ancient art?

6. *Mosaic*: What type of mosaic would be most satisfying to live with? What would influence the choice of design for a mosaic floor? Apart from durability what would be the advantages of this type of flooring? Search out illustrations of the mosaics of Cyprus, Antioch-on-the-Orontes or Piazza Armerina. What might have been the reasons for commissioning a mosaic copy of a painting or very detailed scene for your floor? In any form of art, is the simple always more elegant?

7. *Silver and the Decorative Arts*: Livy and Pliny repeatedly write of art in terms of booty. Do you think the fact that so much art came to Rome from captured cities affected Roman attitudes? Read the satirical account of Trimalchio's dinner party in *The Satyricon* by Petronius. Can desire for conspicuous display lead to real appreciation of art? In museums look at the silver and bronze etc. and try to decide how much was for use and how much for display.

8. *Art as Propaganda*: What image of Rome and himself was Augustus trying to create? Can something created for such a purpose be a great work of art? Look at examples of public art from the Stalinist Soviet Union. What are they trying to convey? What sort of images of our society do the creative arts present?

9. *The Purpose of Art*: Is art resulting from the artist's own inspiration likely to be more important than art commissioned by a patron? Is art appreciation objective or subjective? Has art a moral purpose? If you are interested in such questions of aesthetics, a good starting point is *The Story of Art* by E.H. Gombrich.

Suggestions for Further Reading

Original Sources

Pliny the Elder's *Natural Histories* XXXIII-XXXVI give a good histori-
cal account laced with anecdote of the coming of Greek art to Rome. For
a more technical angle see Books VI and VII of Vitruvius' ten books on
architecture. The most relevant chapters as well as other extracts from
ancient authors that refer to art and criticism are collected by J.J. Pollitt,
(ed.) *The Art of Rome c.753 BC-337 AD: Sources and Documents* (Cam-
bridge, 1983). Pliny and Vitruvius are also available in the Loeb series
of translations.

General Books

1. Boardman, John, ed., *Oxford History of Classical Art* (Oxford, 1997)
2. Brilliant, Richard, *Roman Art from the Republic to Constantine*
 (London, 1974)
3. Burn, Lucilla, *The British Museum Book of Greek and Roman Art*
 (London, 1991)
4. Claridge, Amanda, *Oxford Archaeological Guides: Rome* (Oxford,
 1998)
5. Elsner, Jaš, *Art and the Roman Viewer* (Cambridge,1995)
6. Grant, Michael, *Cities of Vesuvius* (London, 1971)
7. Henig, Martin, ed., *Handbook of Roman Art* (Oxford, 1983)
8. Strong, Donald, *Roman Art* (Harmondsworth, 1980)
9. Ramage, Nancy H. and Andrew, *Roman Art* (Cambridge, 1991)
10. Toynbee, J.M.C., *The Art of the Romans* (London, 1965)
11. Wheeler, R.E.M., *Roman Art and Architecture* (London, 1964)
12. Zanker, Paul, *The Power of Images in the Age of Augustus, transl.*
 Shapiro (Ann Arbor MI, 1988).

These general books cover most aspects of Roman Art, usually taking
an historical approach, apart from (7), which contains chapters on all
genres of art written by specialists. (2 and 8) give most emphasis to
sculpture and relief. (1, 3 and 9) are particularly well illustrated in colour

and black-and-white. (6) is not strictly a book about art, but the illustrations (all drawn from Pompeii, Herculaneum and the National Archaeological Museum, Naples), and the chapter on Paintings, Mosaics and Furniture, are particularly good. (3) is invaluable for locating and understanding works of art still *in situ* in Rome. For an excellent account of the part played by art in Roman life, both public and private, see (12) which is both readable and well illustrated. (5) takes an art historian's approach and the technical language may not appeal to all. Though an older book, (10) remains a readable and comprehensive account.

Specialised Subjects

This list gives a selection from the enormous number of books dealing with specialised areas. The list includes the catalogues (*) of past British Museum exhibitions which have full introductions to the subject, both artistic and archaeological, as well as detailed discussion of individual items and superb photographs. Books on mosaics are usually by area or site, e.g., Cyprus, Piazza Armerina, etc., and have to be hunted out in library catalogues.

Clarke, John R., *Roman Black-and-White Figural Mosaics* (New York, 1979)
Farrar, Linda, *Ancient Roman Gardens* (Stroud, 1998)
Fischer, Peter, *Mosaics* (London, 1971)
Harden, Donald B., *Glass of the Caesars* (Milan, 1987)*
Hekler, Anton, *Greek and Roman Portraits* (London, 1912)
Higgins R., *Greek and Roman Jewellery* (London, 1961)
Johns, Catherine & Potter, Timothy, *The Thetford Treasure* (London, 1983)*
Kleiner, Diana E.E., *Roman Sculpture* (Yale, 1982)
Koortbojian, Michael, *Myth Meaning & Memory on Roman Sarcophagi* (London, 1995)
Ling , Roger, *Ancient Mosaics* (London, 1998)
Ling, Roger, *Roman Painting* (Cambridge, 1991)
L'Orange, H.P. & Nordhagen, P.J., *Mosaics, transl. Keep* (London, 1996)
Richter, Gisela M.A., *Roman Portraits* (New York, 1948)
Strong, D.E., *Greek and Roman Gold and Silver Plate* (London, 1966)
Strong, D.E., *Roman Imperial Sculpture* (London, 1961)
Toynbee, J.M.C., Roman Historical Portraits (London, 1978)
Vermeule, Cornelius C., *Greek Sculpture and Roman Taste* (Ann Arbor, Michigan. 1977)

Walker, Susan & Bierbrier, Morris, *Ancient Faces, Mummy Portraits from Roman Egypt* (London, 1997)*
Walker, Susan, *Greek and Roman Portraits* (London, 1995)

Readers particularly interested in Art in Roman Britain should see the book of that title by J.M.C. Toynbee (London, 1962), and *Art in Britain under the Romans* (Oxford, 1964) by the same author. The affordable Shire Books series, on sale in most museum shops, is a good way into specialised study of Romano-British art, particularly the following:

Allen, D., *Roman Glass in Britain* (Shire Books, Princes Risborough, 1998)
Bedoyérè, Guy de la, *Samian Ware* (1988)
Johnson, Peter, *Romano-British Mosaics* (1995)
Johnston, David E., *Roman Villas* (1994)
Ling, Roger, *Romano-British Wall Painting* (1985)
Rook, Tony, *Roman Baths in Britain* (1992)

Glossary

acroteria Ornaments at the corners of roofs, sarcophagus-lids and steles.

aedicula Small shrine or pavilion.

andamento Course of the lines of *tesserae* in a mosaic.

antefix Ornament, usually of terracotta, attached to a gable end.

apotheosis The process of becoming a god – in art shown as an emperor or empress being carried to heaven.

arabesque Decoration in the form of plant tendrils.

attic Uppermost element of a triumphal arch, which might have reliefs on the faces and sculptures above.

Baroque Elaborate style with rich ornament; usually used of seventeenth-century architecture, etc.

Chi Rho XP, the Greek letters used as a monogram for Christ.

chiaroscuro Use of light and shade to enhance a painting or sculpture.

conclamatio A scene of mourning.

damnatio memoriae Public disgracing by the obliteration of all portraits, etc. of the departed.

diatreta Cut glass, particularly used of cups cut so as to appear to be in two layers.

emblema, -ata Detailed focal point of a mosaic, usually prefabricated.

ephebe Young Athenian citizen under military training.

Genetrix Mother; used of mature depictions of Venus as mother of Aeneas, legendary ancestor of the Julian family.

gravitas Serious-mindedness; a quality much valued in republican Rome.

grotesques motifs combining figures of satyrs or animals with tendrils.

guilloche plait or rope pattern, frequently used as border or frame for mosaics.

Hellenistic Refers to period from death of Alexander (323 BC) to Roman conquest of Greece in mid-first century BC.

impluvium Small pool in the atrium of a Roman house to catch the rain that came through the opening in the roof (*compluvium*).

inhabited scroll A carved or painted scrolled pattern containing birds, animals, etc. among the foliage.

intaglio Engraved gemstone.

ius imaginis Right granted to noble families to display ancestors' death masks.

jeux d'esprit Artistic details added for fun.

lanx, lances Rectangular ceremonial platters.

lar, -es God(s) that protected the household.

lararium Their shrine.

neo-Attic, neo-classical Style based on fifth-century models from Athenian and other Greek centres.

numina Unseen divine powers.

nymphaeum, -a Fountain building.

orthostates Large panels in the middle zone of a wall, originally of stone, but later painted.

palaestra Area for exercise, particularly wrestling, at the baths or sports ground.

peristylium, -ia Rectangular courtyard surrounded by a colonnaded walk.

phiale Shallow bowl for pouring drink offering to gods.

pudicitia Modesty; used to describe pose of completely draped female figures.

rinceau, -x A scroll pattern in the form of leafy stems.

sarcophagus Free-standing burial chest, usually stone.

skene Roman stage which had a permanent wall, often decorated with niches, in place of a backdrop.

smalti Vitreous pieces custom-made for mosaics to give a range of colours.

stele Upright slab with inscription and/or carving, often as a memorial.

stilus Pointed writing implement used with wax tablets.

tessera, -ae A small cube of stone, tile or glass used to make a mosaic.

tondo, -i A circular panel containing a painting or relief.

triclinium Dining-room.

Verism Style of portraiture which concentrates on true physical features of subject.

vestibulum Entrance hall of a Roman house.

viridarium Garden attached to a house, as opposed to *hortus*, a fruit and vegetable garden.

volute Spiral-shaped decoration.

Index